THE QUEEN
NEXT DOOR

The Queen

Foreword by
BURT BACHARACH

Afterword by
SABRINA VONNE' OWENS

Next Do

Aretha Franklin, *An Intimate*

LINDA SOLOMON

Cover design and interior book design by Amanda Weiss

ISBN 978-0-8143-4728-7 (hardback);
ISBN 978-0-8143-4729-4 (ebook)

Library of Congress Control Number: 2019938101

WAYNE STATE UNIVERSITY PRESS
Leonard N. Simons Building
4809 Woodward Avenue
Detroit, Michigan 48201–1309

Visit us online at *wsupress.wayne.edu*

For Barry . . . always and forever

To my mom and best friend, Mona Rappaport,
whose extraordinary memory for every detail of my life
helped me select the most special times with Aretha.

To my dad, Daniel J. Rappaport, a blessed memory,
whose "respect" and love for music is my inspiration.

In loving memory of Erma Franklin, Carolyn Franklin,
Reverend Cecil Franklin, and our Queen Aretha Franklin,
who gave her heart and her soul to Detroit. My admiration,
gratitude, and R E S P E C T "forever and ever . . ."

FOREWORD

———

Aretha never ceased to amaze me. Vocally, just astonishing. No one like her . . . no one ever will be like her. Her musicality, the way she could work at the piano and be so creative at the piano, never was a sight reader only playing by ear, which was totally amazing to me. I went to record her once in Detroit but talked to her on the phone from LA beforehand about the song we were doing. I played the song and the key I thought would be the right key for Aretha and she said "no." She went to the piano and said it's too low, I can sing it two notes higher. She then sat at the piano and played the song in the key she wanted to sing it in. I was quite astonished . . . she was right on the money. She was just amazing. And to take a song like "Say a Little Prayer," which I thought we had made a pretty good recording of with Dionne, and make Aretha's version . . . it was so much better. I wanted her voice and her life to live forever. I miss her very much.

BURT BACHARACH

THE QUEEN
NEXT DOOR

*"I am the lady next door when
I am not on stage."*

ARETHA FRANKLIN

INTRODUCTION

My love for Aretha Franklin started when I was a kid and I first heard "Respect" on WKNR Radio. On a Saturday afternoon I hopped on the Hamilton bus to Northland Mall and to Kresge's record department to buy her 45.

Growing up in Detroit in the sixties, we would see and often meet the Supremes or the Four Tops at the Michigan State Fair or the Roostertail on Detroit's riverfront. On special Saturdays all my friends would line up outside one of the many record stores in downtown Detroit to ask for autographs from the Four Tops, the Temptations, Martha Reeves and the Vandellas, and Smokey Robinson and the Miracles as they signed their newest records for all the kids. The Motown stars lived near one another in Detroit, and kids like me would stop by their houses to take photos and ask for autographs. I still have my photographs of the Supremes and their autographs. The Queen of Soul was living in New York City and California and touring all around the world at the time.

In wasn't until 1982 that Aretha came back home.

I first met her in April 1983, when I had a weekly Sunday column in the *Detroit News* and just a year after she moved back home. Aretha had moved back to Detroit from Los Angeles to care for her father, the internationally noted civil rights activist Reverend C. L. Franklin, who remained comatose for five years after being shot during an attempted robbery at his home in 1979. This was an emotionally wrenching time in Aretha's life. Aretha and the Franklin family prayed and hoped he would recover, but, tragically, he did not.

I had freelanced for four years photographing celebrities before I became a *Detroit News* columnist in the summer of 1982. I was hired by managing editor Lionel Linder, a wonderful man who had a smart philosophy: hire experts to write about the subjects they were experts in—architects to write about design and judges to

write about law. He felt if I had the chutzpah to capture the most private celebrities with my camera, then I should be the one to interview them too. So I started to write. My goal was to get the photographs and interviews no one else could, and number one on my list was one of the most private of them all—the Queen of Soul.

I was granted that opportunity in 1983 when I learned that Aretha would be a guest on a local TV talk show, *Kelly & Company* in Detroit. I called one of the producers of the show to arrange a story for my column in the *Detroit News*. Aretha allowed me to take her photo not only outside but also while she performed on the show.

My Sunday column featured just a single portrait of her at the piano. In it, I mentioned an upcoming concert benefit she was putting on to support her father's medical trust fund. Shortly after, her assistant contacted me at the *Detroit News* and invited me to a reception Aretha would be attending with her family at the Manoogian Mansion, the official residence of the mayor of Detroit. It was a very small, intimate reception to announce the benefit she was planning for her father. The only guests were Franklin family members and a few close friends, including Motown Executive Vice President Esther Gordy Edwards. I felt so lucky to be included! This was the beginning of my friendship with Aretha.

Aretha invited me to meet her family and closest friends, and she met my family too. My dad was with me when I photographed her in rehearsal with James Brown, and my mom accompanied me when I photographed Aretha at the New York Friars Club Tribute to Clive Davis. My sister, Jill Rappaport, hosted a big bash for Aretha and her family one summer when Aretha was spending time in the Hamptons. She brought her grandkids with her, and she had a camera. I laughed when she asked me if she could take a photo of me. That was Aretha.

She graciously let me capture everything for my *Detroit News* column and later for my television interviews both locally and nationally. I not only respected her privacy, I respected her time. I would never shoot hundreds of photos as many do today with their digital cameras or cell phones. I was never in her face with my camera. I would always ask her first before taking her photograph even though I was invited to her home. I would say to her, "May I have a few seconds to take a photo of you with your sister Erma in the hallway with your gold records?"

Aretha was a strong advocate for women. She never said this to me personally because it was not her style, but I truly believe she gave me so many exclusive opportunities because she knew it would help my career. And it did. I met her when I was only twenty-nine. Everyone in the media knew she rarely granted interviews and, of course, my editors were impressed with my access. She was known for carefully protecting her privacy. She read her press and was sensitive (like most of us) to negative comments or reviews. She watched the local news, and a few noted Detroit broadcast journalists and print journalists became her friends. She treated journalists with respect, and I will forever be grateful for that. She never once asked for photo approval, and she always sent flowers with her handwritten words, "Thank you from Aretha and the Franklin family."

Aretha was doing so many exciting things in the eighties, and so much was happening in Detroit. I could have had a weekly column and television segment devoted to just her! Those years were a major turning point in Aretha's career as she entered a new musical phase with Clive Davis, the president of Arista Records. In 1985, her album *Who's Zoomin' Who?* was certified platinum. The first single released, "Freeway of Love," was a smash hit. The hits would keep on coming. *Who's Zoomin' Who?* was the most hit-filled studio album of her career and her highest-charting album since *Amazing Grace* in 1972. In 1986 her album *Aretha* was certified gold, with hits "I Knew You Were Waiting (for Me)" and "Jumpin' Jack Flash."

If you wanted to work with Aretha in the eighties, you had to come to Detroit. Aretha had a fear of flying and had decided not to travel even by car or customized bus (as she did in later years). Even Keith Richards and Ron Wood of the Rolling Stones came to United Sound Systems in Detroit to record "Jumpin' Jack Flash" with Aretha. And when that song was used as the title song for the film *Jumpin' Jack Flash*, Whoopi Goldberg came to Detroit to appear with Aretha in the music video.

Detroit was featured front and center. All of her television specials and commercials were filmed in Detroit. In 1986, Dick Clark Productions invited Aretha to appear on the annual American Music Awards and arranged for a special satellite hookup to showcase Aretha live from her hometown. Famous producers, directors, and superstars came to Detroit to work with Aretha, and once

again the music industry was focused on Detroit. "I was asked to go to Hong Kong to direct Madonna, but I chose to come to Detroit to work with Aretha," said director Barry Glazer of Dick Clark Productions.

Still, Aretha volunteered to perform at local benefits in Detroit and volunteered her time to answer phones for local telethons. (Imagine if the callers had known they were speaking to Aretha!) She brought superstars to Detroit to record public service announcements with her and held concerts at local venues and with the Detroit Symphony Orchestra. She loved hosting lavish birthday and holiday parties at her home and always featured local musicians and singers in her living room. She promoted the talents of local florists, caterers, and fashion designers. When she was in Detroit, she enjoyed Red Lobster and Big Boy. So many Detroiters will tell you their stories of seeing a Cadillac limousine outside of neighborhood restaurants Steve's Deli and Beans & Cornbread. Aretha Franklin would be there having lunch with her family and friends.

Once, shopping at my neighborhood Kroger grocery store, I saw this low-key lady in the produce section and was surprised when I realized it was Aretha. That is who she was—"the lady next door" who just happened to be an international treasure. When I was in line to check out, I said to the cashier, "Aretha is in the next aisle." Her response: "She is always here!"

Even as "the Queen," revered and adored, Aretha lived an authentic life where she could always be herself—"a natural woman," indeed. She started singing in the choir at her father's church, New Bethel Baptist Church, when she was thirteen. Aretha always gave back to the church and to the city she loved and respected. In 1987, Aretha even rejoined the choir at New Bethel Baptist for the first album she ever produced entirely alone, *One Lord, One Faith, One Baptism*. "This is *my* home," she said.

My husband and I got to know Aretha and her wonderful family, including her sons; her beloved siblings Erma, Carolyn, and Cecil; her nieces Sabrina and Cristal; her cousin Brenda; and her closest friends. Her brother, Reverend Cecil Franklin, was her manager, and he would call to invite me to photograph Aretha at private rehearsals for her concerts, national commercials, music videos, and TV specials—the intimate moments one rarely sees of a superstar. I loved capturing her at her home singing at the piano and in her bedroom hallway, which was adorned with family photos and gold and platinum records. Her guests at her private

parties included her family and closest friends the Four Tops, the Spinners, the Staple Singers, and the Reverend Jesse Jackson. I'm still pinching myself as I write this, knowing the incredible honor it was to be in her inner circle and to be asked to document so many exciting years in her career during the iconic eighties.

Aretha had impeccable manners, always introducing me as "Miss Solomon" when I was on assignment with her, and always giving personal attention to her party guests, even down to the invitations. I have saved all her beautiful invitations with her own handwriting in metallic silver pen on each envelope and inside the invitations with directions to her home. The Queen personally addressed all her invitations—mine were to "Linda and Barry" (my husband). She loved her parties and planned everything from the design of the invitation to the menu to the music. I also received a beautifully engraved invitation with a handmade miniature violin sent to me at the *Detroit News*. It was from Aretha inviting me to her Christmas party. I was stunned!

She invited me to photograph her in exquisite and sexy gowns, and let me tell you—this Queen had jewels that would make an actual queen emerald green with envy! I once heard she was jewelry shopping in Detroit and said to the sales associate, "I will take it." The sales associate asked her, "Which one?" And Aretha responded, "The entire case!" She wore statement earrings and turquoise nail polish way before it was trendy. And of course, her designer handbag was always on the piano in rehearsal and in concert. But I also captured the legendary star in her loafers and casual cardigans, in "the moment I wake up before I put on my make up" (to quote a great Aretha verse), and she was always just as radiant and regal.

We would chat and have girl talk on the phone about everything from fashion to the latest diets. She was just like the rest of us, wanting to know the scoop and latest trends. She had a great sense of humor and always sweetly laughed when we discussed the handsome Burt Bacharach. She was also modest, a quality that was reflected in the voicemail messages she left me: "Hi Linda," she'd say. "It's Aretha calling . . . Aretha [pause] Franklin." I always smiled to myself when she left her last name. I saved many of her messages, just to be able to hear that incredible sweet voice whenever I wanted.

In the nineties, Aretha started to travel again in her custom bus, and she performed all over the country. She still performed in Detroit but not as frequently as in the eighties. She continued to generously give back to her hometown, to New Bethel Baptist

Church, and to those in need. She continued to help people she read about or heard about, and she did this anonymously.

While she traveled, I would stay in touch by phone. No one had as many telephone numbers as Aretha Franklin. Every time she would leave her phone number, I would call back to find that the number had already been disconnected. I would have to call one of her relatives to find out her new number. I had, at last count, over one hundred in my iPad just for her! In 2007, I called Aretha to interview her for my book *The Key: The Celebrated Unlock Their Secrets to Life*. I asked Aretha, "What is the key to respect?" She quietly said to me, "Acknowledging that the world does not revolve around you alone."

From 2010 onward, I didn't see Aretha. She was on the road performing in concert and for presidents. I was on the road teaching children living in shelters how to share their hopes and dreams with a camera for my program Pictures of Hope. I had heard during these years she had been hospitalized. I respected her privacy and never shared with anyone what I knew, and I did not call her. I also knew this is what she would have wanted most: her privacy.

In 2014, I received a Facebook friend request from Kay Cunningham, who messaged me to share that "Kay" is really "Aretha." She posted personal photos (she often carried a professional camera) of family celebrations and her exciting travels. Before she stopped posting, she also shared her heartfelt feelings on finding a cure for cancer, the dreaded disease that eventually took her life. The Queen of Soul, beloved and admired all over the world, had only twenty-two friends on Facebook. I am one of the lucky twenty-two.

So many stars who are from Detroit left our city and never came back, but not Aretha. When she returned in 1982, Detroit,

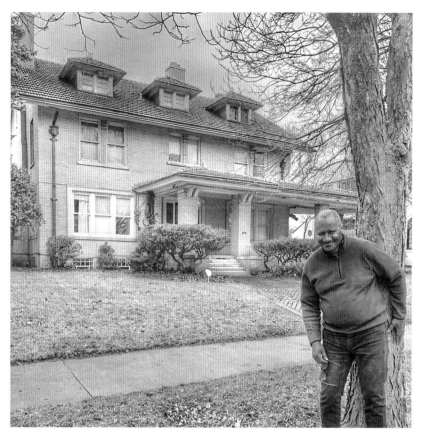

Aretha's oldest son, Clarence, in front of his mother's childhood home.

the city where she learned to sing, was again her home. She truly loved this city, and the Queen of Soul gave both her heart and her soul to us. She is to Detroit what Elvis is to Memphis. And just like Memphis, where everyone has an Elvis story, Detroiters have their Aretha stories.

What follows are my photographs of "the Queen" on stage and of "the lady next door." It is an honor to share these memories of the most special times I had photographing Aretha, and I am so fortunate to have known her. I am blessed our paths would cross during a very exciting and fun time in her remarkable life and in her outstanding career, and I am so lucky the "lady next door" became my friend.

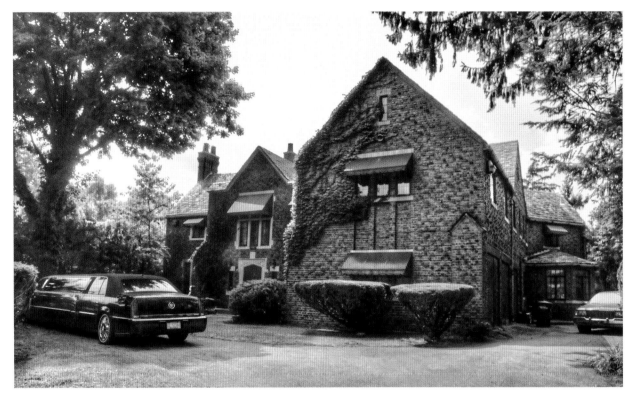

Aretha's Detroit home, with her two Cadillac limousines in the driveway, is a 1927 Tudor on the seventh hole of the Detroit Golf Club.

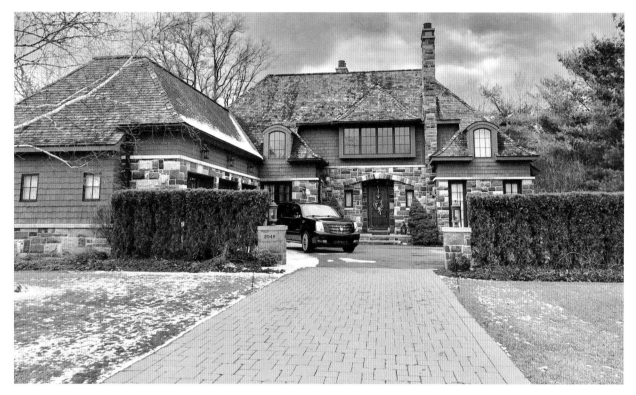

Aretha's Bloomfield Hills home in suburban Detroit is in a private gated community. Like the Detroit home, it has a two-story living room. Aretha's piano was placed under the portraits of her four sons and her father, Reverend C. L. Franklin.

19
—
83

APRIL

Singing at the Piano . . .

———

The morning Aretha was scheduled to appear in Detroit on local talk show *Kelly & Company*, I waited outside the ABC local affiliate studio for her to arrive. I will always remember seeing her step out of her limousine. She smiled sweetly when I asked if I could take just one photograph of her and said, "Yes." I thanked her and shared how happy I was to meet her and how glad I was that she had moved back to Detroit. She graciously thanked me.

As she walked into the studio, I asked if I could take a couple more photographs of her performing and she said, "Sure." She sang and played piano for a studio audience of seventy-five people. She was forty-one years old when I took my first photo of her. Aretha was dressed elegantly in black suede and white charmeuse and wore a turban. She also wore eyeglasses, which I would never see her in again. I stayed true to my word and took only three photographs, which I think she appreciated.

When Aretha performed, she shared her heart and her soul. For the audience that morning, hearing Aretha proudly proclaim "I love to be home!" was simply magical.

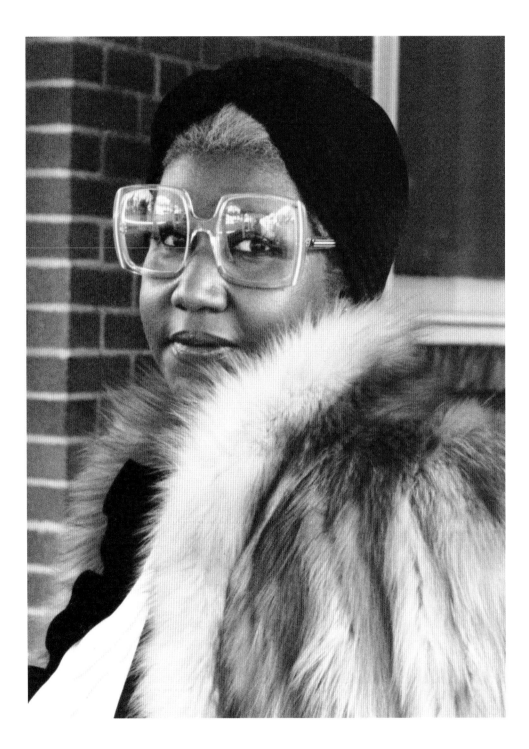

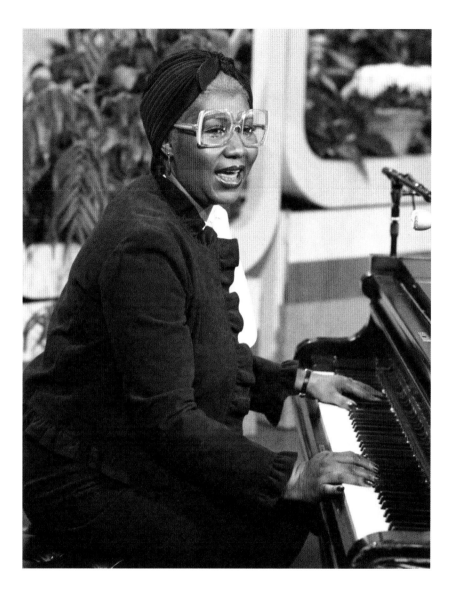

Star Tracks

Linda Solomon

Aretha

Detroit's own First Lady of Soul, Aretha Franklin, has acquired some 12 Grammys and 24 gold records during her performing career. And now, she's anxiously awaiting the release of her newest album in June entitled *Do It 'Til You Get It Right*. "I'm really excited because my son, Clarence, has written one of the songs featured on the album, entitled *Giving In to You*, and my other son, Teddy, played guitar on the album."

Twice-married but currently single Aretha has two other sons; she turned 41 last month. For a recent *Kelly & Company* appearance (she's pictured at left playing the studio piano), she arrived in a black ultrasuede skirted suit with a white silk blouse, black turban and full-length fox fur. She says she "just loves to be home," having moved into a six-bedroom, five-bath Bloomfield Hills residence last winter. She maintains a second home in Encino, Calif.

When Aretha isn't touring, she unwinds by playing tennis and listening to her favorite performers, amongst them another Detroit favorite, the Four Tops. "I think the Tops are the greatest — we have been friends for a long time and have performed and recorded together."

For special moments in her career, she singles out "performing for the queen of England during the Royal Variety Show and President Carter's Inaugural Gala. These two events were highlights in my life."

She began singing at age 12 in the choir at the New Bethel Baptist Church in Detroit. Her father, the Rev. C.L. Franklin, conducted services. Aretha is planning a kickoff party to be held at the Michigan Inn on June 24 to benefit a medical trust fund set up in honor of her father, who was shot during a burglary at his home and has remained comatose for four years.

19
—
83
MAY

The Franklin Family at the Mayor's Residence

———

It was during Detroit Mayor Coleman A. Young's reception for the Franklin family at the Manoogian Mansion that I observed the importance of family to Aretha. She included her family in everything and they went with her everywhere.

At this gathering, I had the opportunity to meet Aretha's family: her son Eddie, her older sister Erma Franklin, her younger sister Carolyn Franklin, her brother and business manager Reverend Cecil Franklin and his wife, Earline, and their young daughter Cristal. Dr. Claude Young, the mayor's cousin and the Franklin family physician, attended, as did close family friend Beverly Bradley and Motown Executive Vice President Esther Gordy Edwards and her son Robert Bullock.

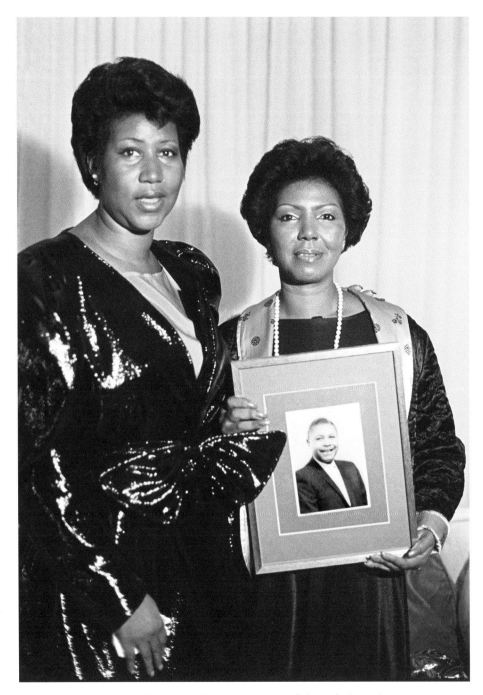

Aretha and her sister Erma holding a portrait of their father, the internationally noted civil rights activist Reverend C. L. Franklin.

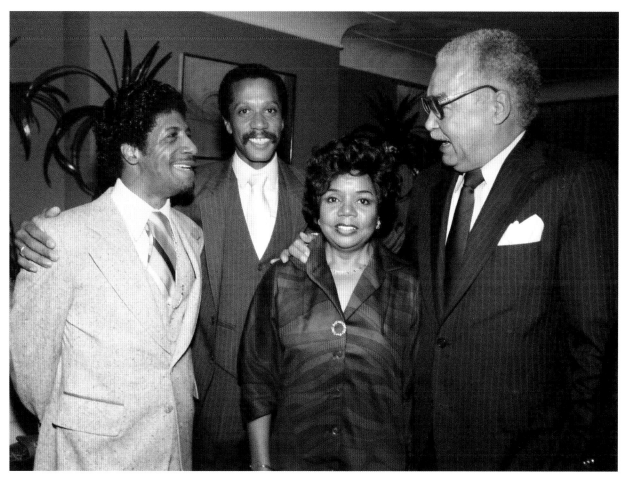

Aretha's brother Reverend Cecil Franklin, Robert Bullock and his mother, Senior Vice President of Motown and founder of the Motown Museum Esther Gordy Edwards, and Mayor Coleman A. Young (LEFT TO RIGHT).

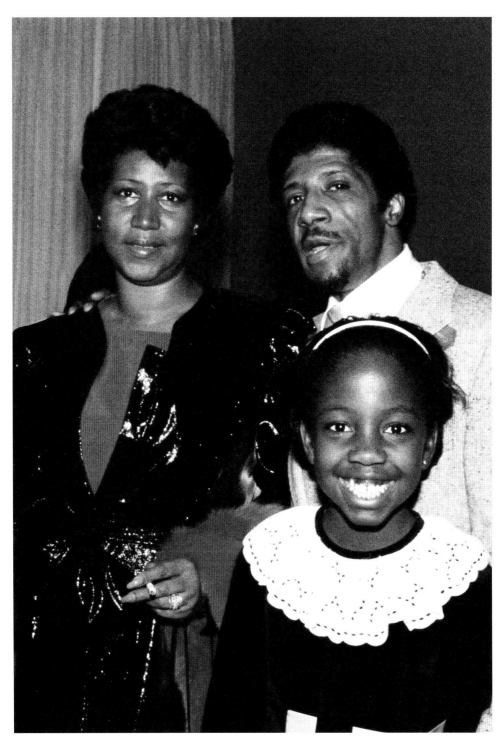

Aretha with her brother, Cecil, and his daughter, Cristal.

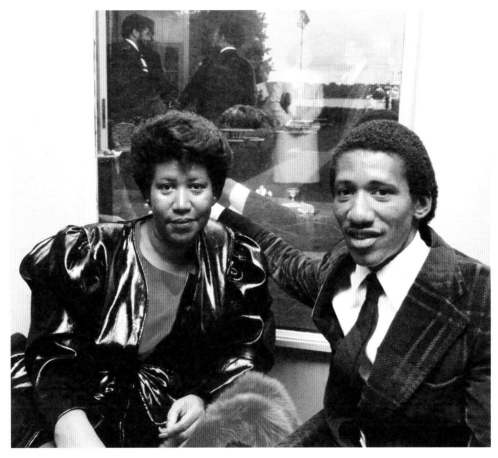

Aretha and her son Eddie.

19
—
84

JUNE

Aretha's Heartfelt Concert

———

Aretha's father, Reverend C. L. Franklin, was in a coma after being shot during a robbery at his residence in Detroit in 1979. The Franklin family decided to put on a benefit concert for their beloved father and held it in the ballroom of the Westin Hotel in Detroit's Renaissance Center (now the Marriott) in downtown Detroit.

Of course, it included an emotional performance by Aretha. The Detroit community and media attended, selling out the concert quickly. At the end of the evening, the Franklin family joined Aretha on stage to thank the patrons for their devotion and support. It was only fitting that the Franklin family host a concert that was open for all to celebrate and help Reverend Franklin.

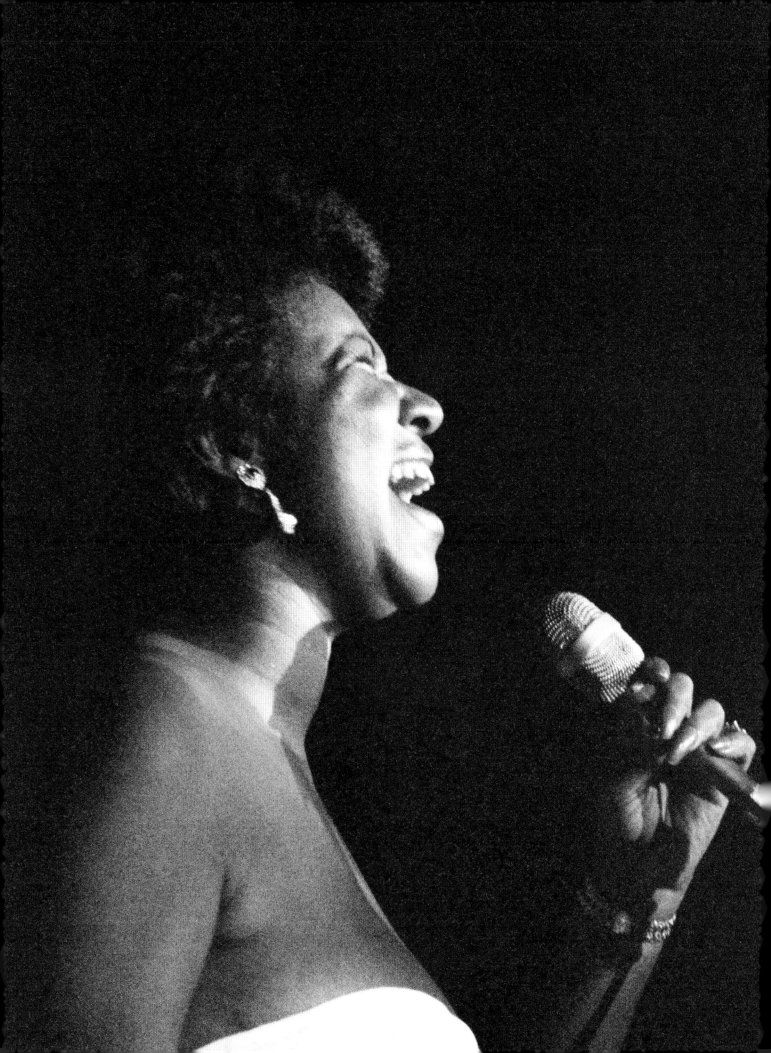

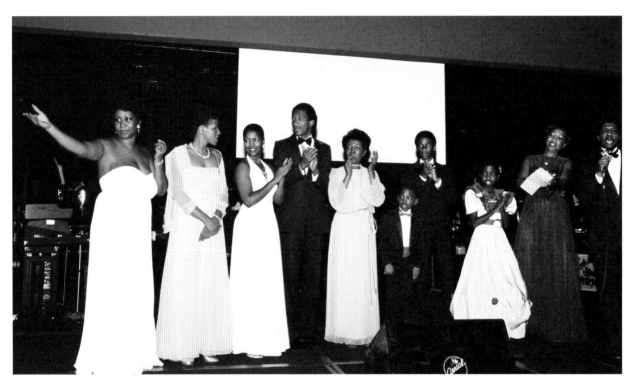

Aretha, her sister Carolyn, her niece Sabrina, her son Eddie, her sister Erma, Sabrina's son LaRone, Aretha's son Kecalf, and Aretha's niece Cristal and her parents, Earline and Cecil (LEFT TO RIGHT).

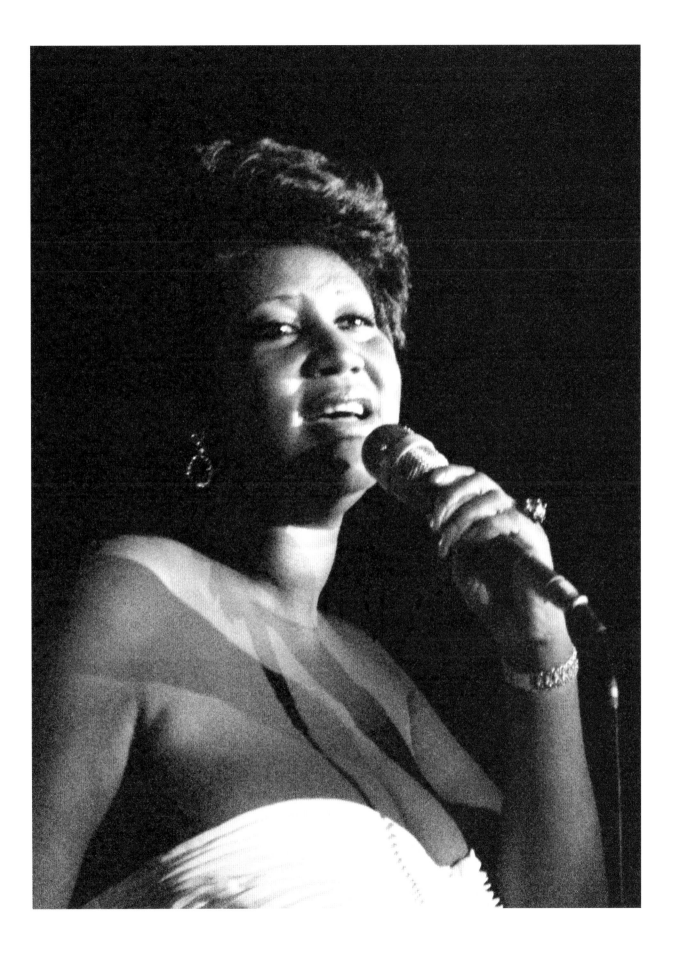

19
—
85

APRIL

Helping Others

———

I magine calling to pledge a donation and hearing Aretha Franklin's voice?! Aretha volunteered to take pledges at the annual Easter Seals telethon in downtown Detroit at WDIV Channel 4. I covered her appearance for my column and saw how much excitement she created when she arrived at the TV studio.

In addition to taking phone pledges, she signed autographs for everyone. Easter Seals is just one of the many charities Aretha supported. She would often read about someone in Detroit who needed help and would reach out to help anonymously.

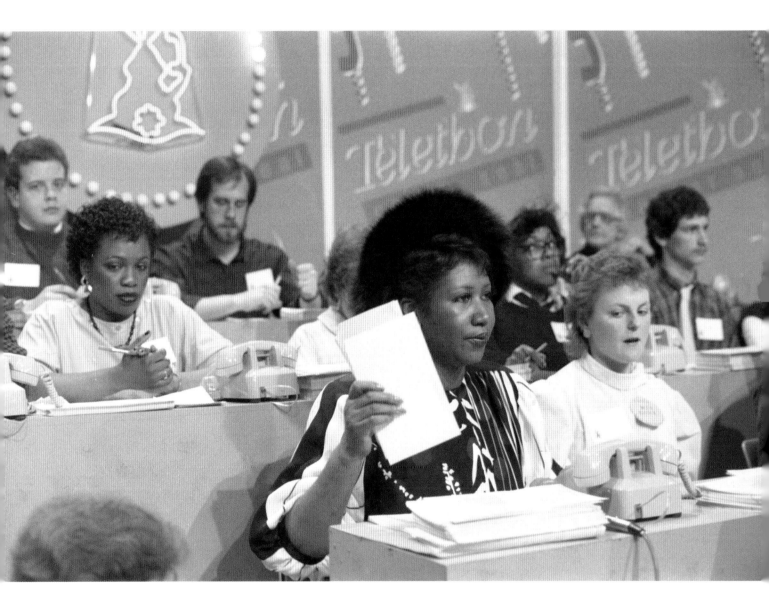

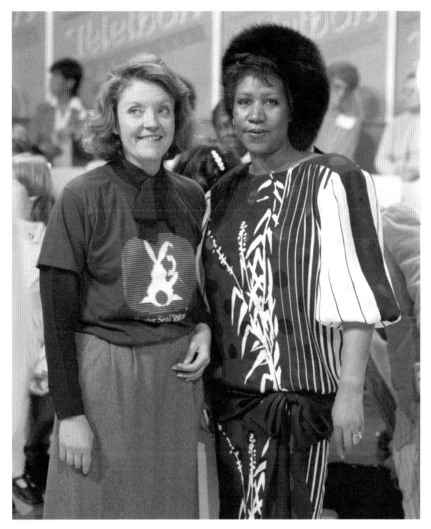

Aretha with Amy McCombs, former general manager and vice president, WDIV NBC Detroit.

President and general manager of WDIV-TV, Amy McCombs (left) with Aretha Franklin on the set of WDIV's Easter Seal Telethon.

Click! Linda Solomon

Easter Seal Telethon helped by Queen of Soul

Channel 4 raised over one million dollars for this year's Easter Seal Telethon with a little help from Detroit's own queen of soul, **Aretha Franklin**. Ms. Franklin created quite a stir when she showed up in the station's "green room," looking smashing in a black and white silk chemise. While she was there, she politely signed autographs for everybody, including telethon stage director **Randy Henry**.

19
—
85

AUGUST

Recording with Motown Stars

———

Famous supporters of Detroit Mayor Coleman A. Young gathered together at Sound Suite Studios in Detroit on a Sunday night to record a reelection campaign song. The song "Power for Tomorrow," written by Paul Riser of Motown, included the lyric "With Mayor Young leading one more time, Detroit will be just fine!" Besides Aretha, the Detroit stars included Aretha's sister Carolyn, Levi Stubbs of the Four Tops, Martha Reeves, Kim Weston, and children too, including Cristal, Aretha's niece.

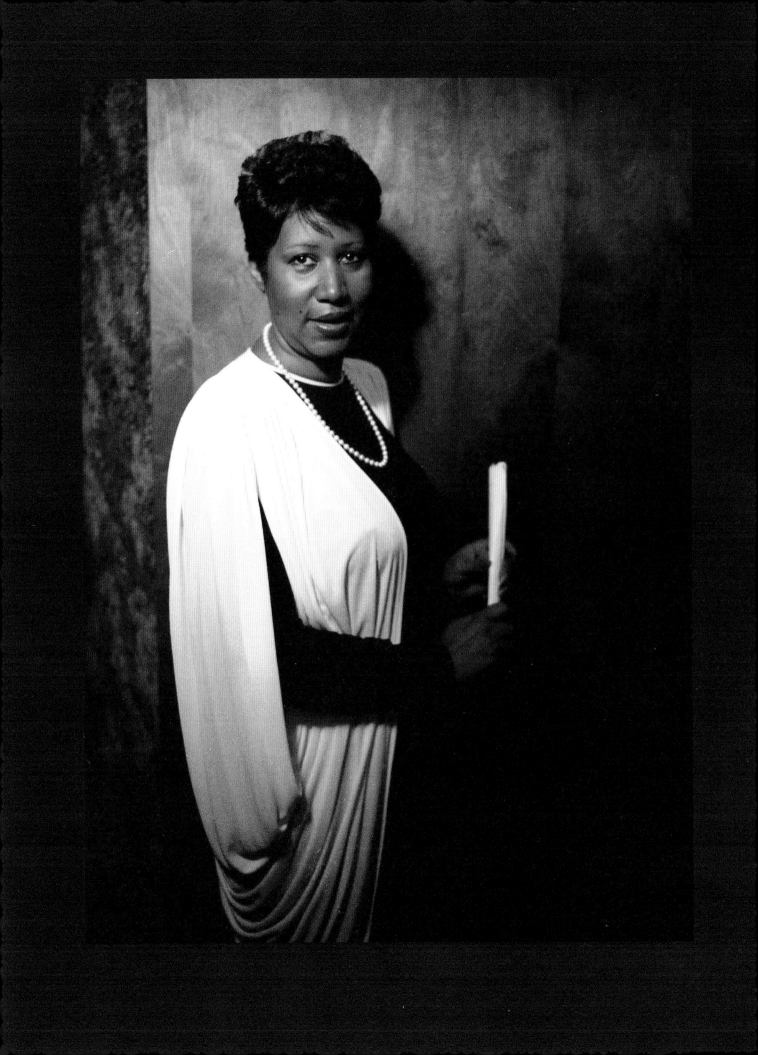

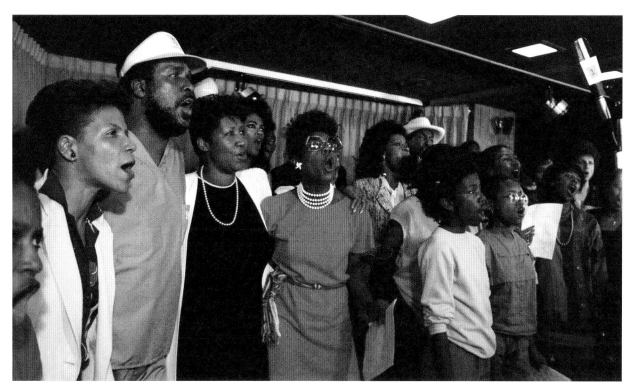

The great voices of Levi Stubbs, Martha Reeves, and Carolyn Franklin join Aretha's in the Detroit recording studio.

Aretha and her sister Carolyn.

Aretha and Levi Stubbs.

19
—
85

SEPTEMBER

Standing-Room Only Concerts

———

"Singing with my sisters is a career highlight for me," Aretha said during her three-night engagement at the Premier Center in Sterling Heights, Michigan, where she highlighted her new album *Who's Zoomin' Who?* Since family was first and foremost with Aretha, her sisters and cousin joined her on stage for all three standing-room only concerts. I was so fortunate to be invited to the concerts and backstage for the private reception with Aretha and her family and friends.

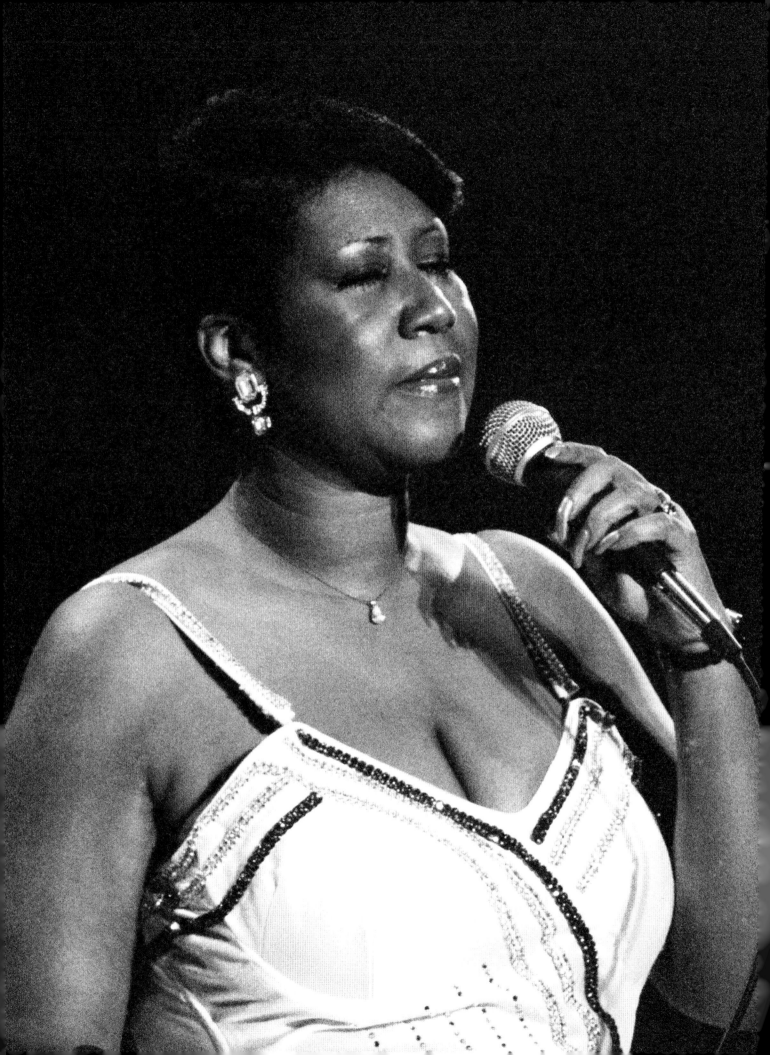

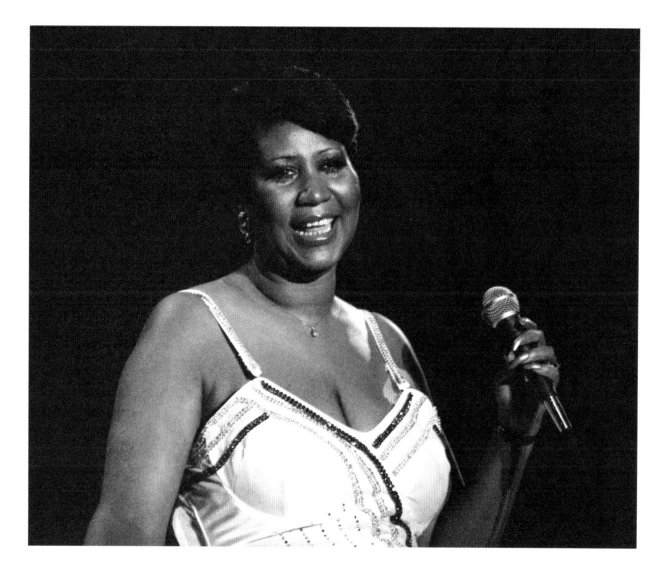

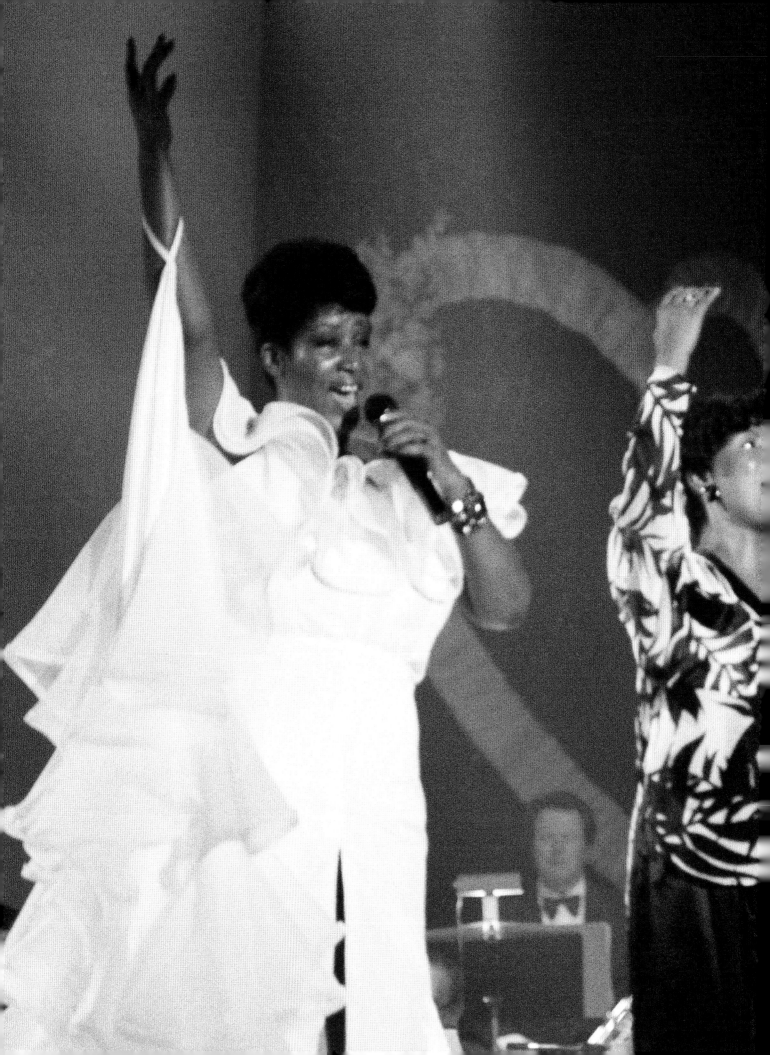

Aretha with her sisters, Erma and Carolyn Franklin, and cousin Brenda Corbett on stage. Aretha often said performing with her sisters and their cousin Brenda was the happiest time on stage.

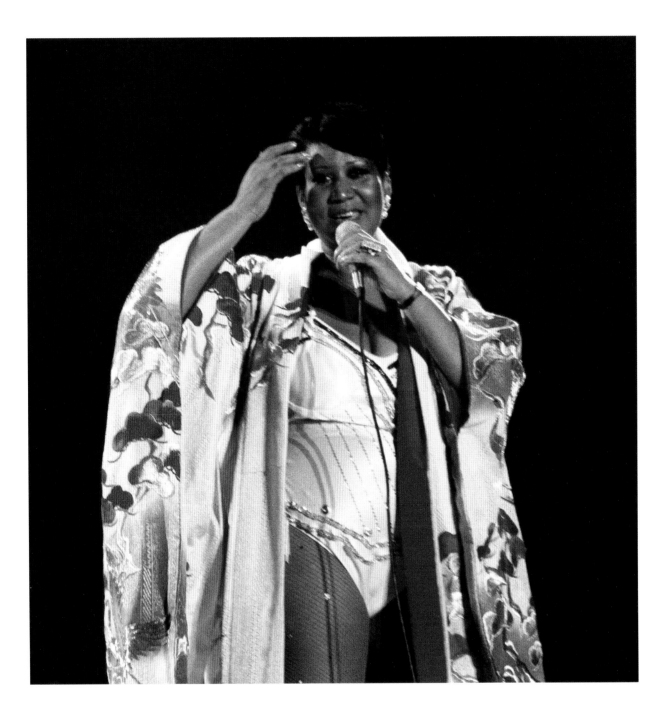

Aretha's son Teddy Richards backstage with Detroit Lion Billy Simms.

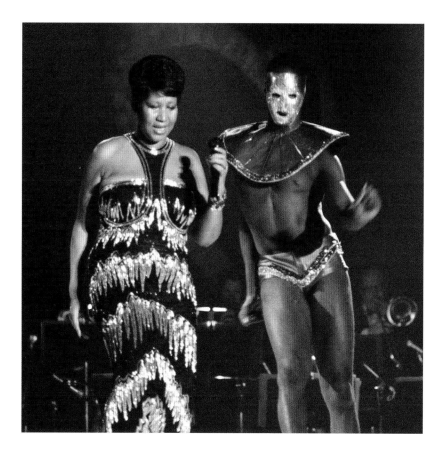

19
—
85

OCTOBER

Detroit Institute of Arts Benefit

Even the invitation was star-shaped to highlight superstar Aretha when she performed at a private benefit for the Detroit Institute of Arts, hosted by Kmart, at their corporate headquarters in suburban Detroit. All of the invited guests (including the star, Aretha) were patrons of the DIA and were on the planning committee for the museum's annual "Night Under the Stars" gala benefit. This night with a star concluded with an exciting surprise. Each guest was presented with the special gift of Aretha's newest and hugely successful album, *Who's Zoomin' Who?*

Aretha entertained guests in the Kmart corporate dining room with a riveting repertoire of her many hits.

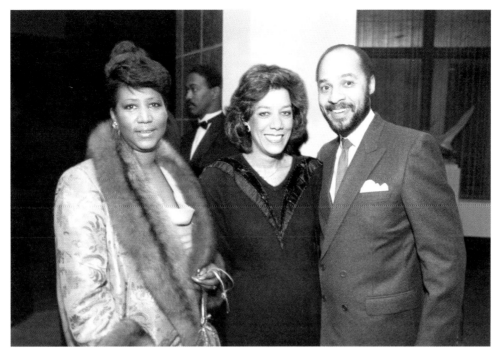

Aretha with Dennis Archer (Detroit's mayor from 1994 to 2001) and his wife, the Honorable Trudy DunCombe Archer.

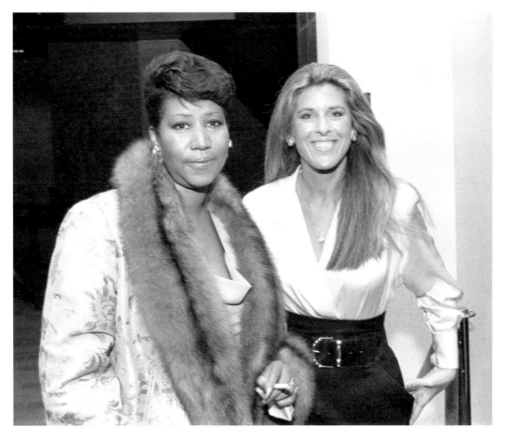

Aretha and me.

$$\frac{19}{85}$$

DECEMBER

Christmas at Home

———

I was so flattered to receive an invitation to my first Christmas at Aretha's. Aretha loved hosting a beautiful Christmas party for her family and friends every year at her home in Detroit. Concert violinists performed Christmas songs as the forty guests arrived at Aretha's house, which glistened with tiny pink Italian lights.

> The exquisite tree and floral arrangements were all in baby pink to symbolize the lyric "pink Cadillac" in her hit song "Freeway of Love." Her guests included Esther Gordy Edwards and her brother Robert Gordy, who flew in from Los Angeles for the holiday party. Aretha's close pals Billy Henderson and his wife, Barbara, attended, as did Erma, Cecil and Earline, and Dr. Claude Young, cousin of Detroit Mayor Coleman A. Young.

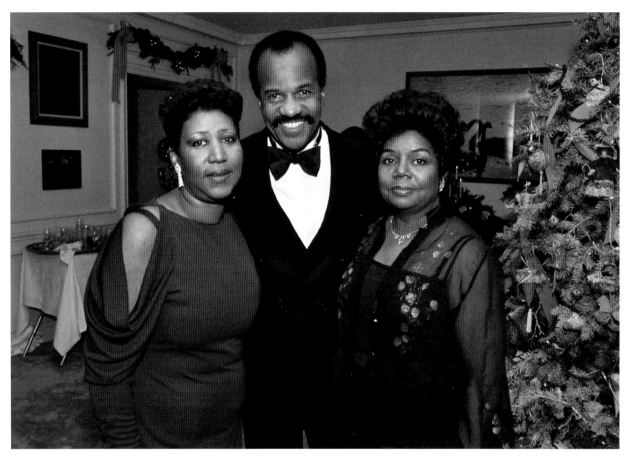

Aretha with Senior Vice President of Motown and founder of the Motown Museum Esther Gordy Edwards and her brother Robert Gordy, vice chairman of Motown Publishing.

Dr. Claude Young and Carolyn Franklin.

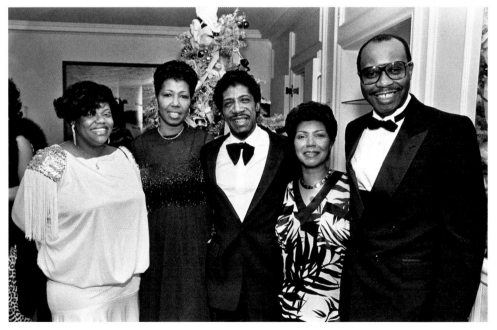

Aretha's cousin and backup singer Brenda Corbett, Earline and Reverend Cecil
Franklin, Erma Franklin, and cousin James Corbett (LEFT TO RIGHT).

One of the highlights of the fun and beautiful party was when Aretha's twenty-eight-year-old son Eddie surprised his mom by singing "This Christmas" to her.

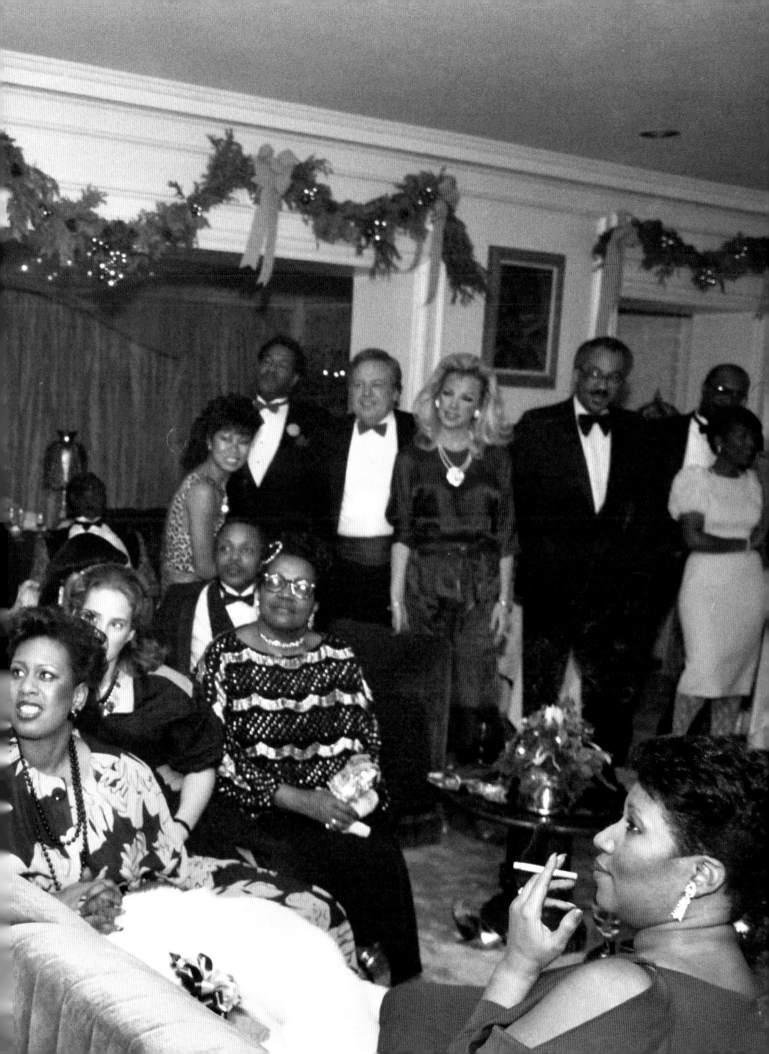

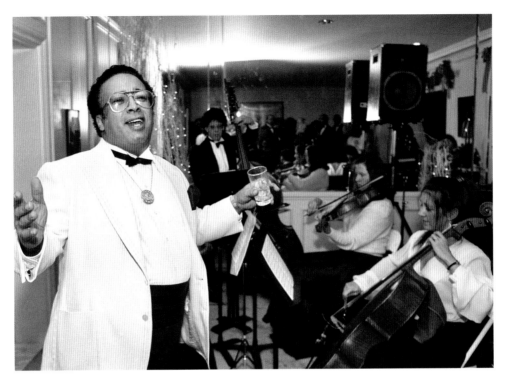

Billy Henderson of the Spinners.

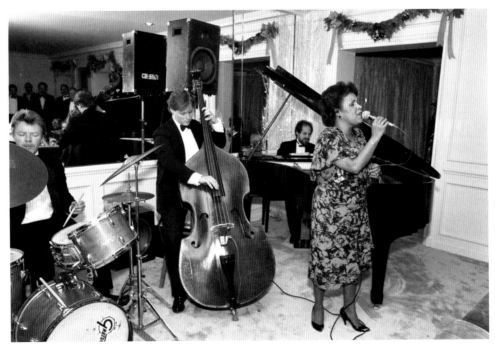

Detroit jazz singer Ursula Walker and the Buddy Budson Trio entertained
after dinner.

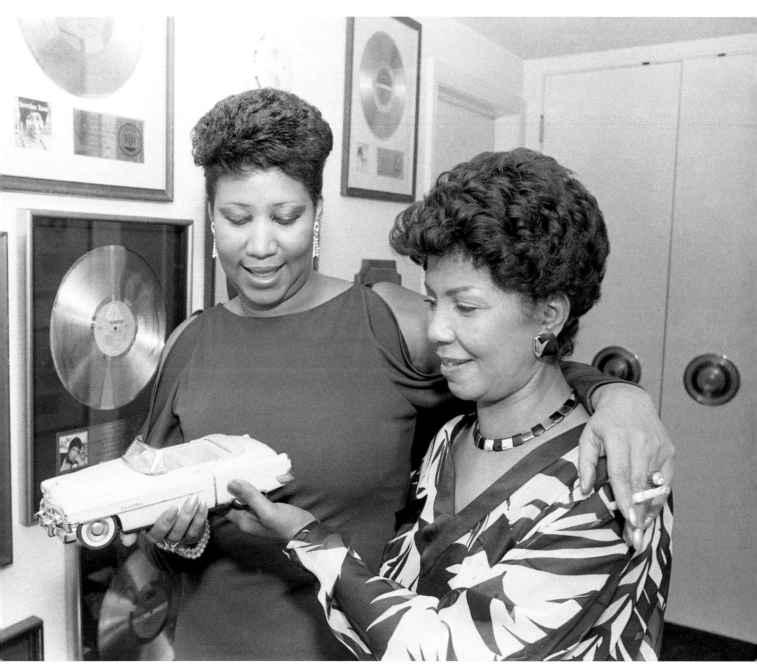

Aretha and her sister Erma admired Aretha's Christmas gift from Narada Michael Walden, the producer
and composer of "Freeway of Love" . . . a miniature pink Cadillac! Aretha and Erma are in Aretha's
bedroom hallway, which is adorned with gold and platinum records.

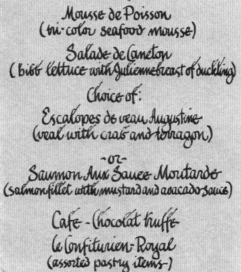

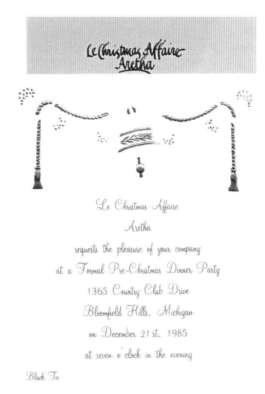

Aretha included a miniature handmade violin with every guest's invitation to "Le Christmas Affaire" at her suburban Detroit home.

Lavish dinner menu.

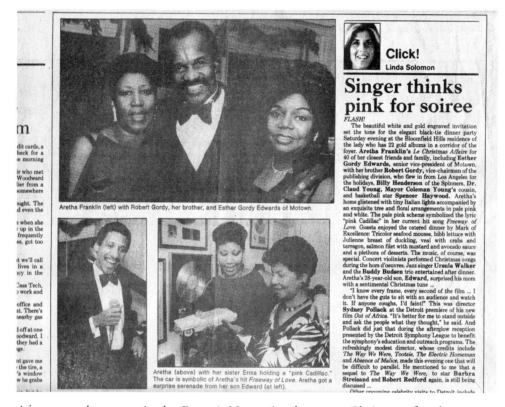

Singer thinks pink for soiree

FLASH!

The beautiful white and gold engraved invitation set the tone for the elegant black-tie dinner party Saturday evening at the Bloomfield Hills residence of the lady who has 22 gold albums in a corridor of the foyer. **Aretha Franklin's** *Le Christmas Affaire* for 40 of her closest friends and family, including **Esther Gordy Edwards**, senior vice-president of Motown, with her brother **Robert Gordy**, vice-chairman of the publishing division, who flew in from Los Angeles for the holidays, **Billy Henderson** of the Spinners, **Dr. Claud Young**, Mayor **Coleman Young's** cousin, and basketball star **Spencer Haywood**. Aretha's home glistened with tiny Italian lights accompanied by an exquisite tree and floral arrangements in pale pink and white. The pale pink scheme symbolized the lyric "pink Cadillac" in her current hit song *Freeway of Love*. Guests enjoyed the catered dinner by Mark of Excellence: Tricolor seafood mousse, bibb lettuce with Julienne breast of duckling, veal with crabs and tarragon, salmon filet with mustard and avocado sauce and a plethora of desserts. The music, of course, was special. Concert violinists performed Christmas songs during the hors d'oeuvres. Jazz singer **Ursula Walker** and the **Buddy Budsen** trio entertained after dinner. Aretha's 28-year-old son, **Edward**, surprised his mom with a sentimental Christmas tune ...

"I know every frame, every second of the film ... I don't have the guts to sit with an audience and watch it. If anyone coughs, I'd faint!" This was director **Sydney Pollack** at the Detroit premiere of his new film *Out of Africa*. "It's better for me to stand outside and ask the people what they thought," he said. And Pollack did just that during the afterglow reception presented by the Detroit Symphony League to benefit the symphony's education and outreach programs. The refreshingly modest director, whose credits include *The Way We Were, Tootsie, The Electric Horseman* and *Absence of Malice*, made this evening one that will be difficult to parallel. He mentioned to me that a sequel to *The Way We Were*, to star **Barbra Streisand** and **Robert Redford** again, is still being discussed ...

Other upcoming celebrity visits to Detroit include

Aretha Franklin (left) with Robert Gordy, her brother, and Esther Gordy Edwards of Motown.

Aretha (above) with her sister Erma holding a "pink Cadillac." The car is symbolic of Aretha's hit *Freeway of Love*. Aretha got a surprise serenade from her son Edward (at left).

After my column ran in the *Detroit News*, Aretha sent a Christmas floral arrangement to my home and thanked me.

$$\frac{19}{86}$$

"Michigan's Precious Natural Resource"

———

Michigan Governor Jim Blanchard and the Michigan legislature declared Aretha's voice a "precious natural resource" and celebrated her at the Detroit Renaissance Center. Among the guests were Michigan Governor James J. Blanchard, U.S. Appellate Judge Damon J. Keith, Detroit Mayor Coleman A. Young, and Aretha's brother, Reverend Cecil Franklin.

Aretha was politically active and campaigned for candidates both locally and nationally, hosting and attending fundraisers for Reverend Jesse Jackson and Mayor Coleman A. Young and volunteering to perform in concert and to do public service announcements. Her devotion to community service and civil rights activism was woven into the fabric of her life by her father and close Franklin family friend Dr. Martin Luther King.

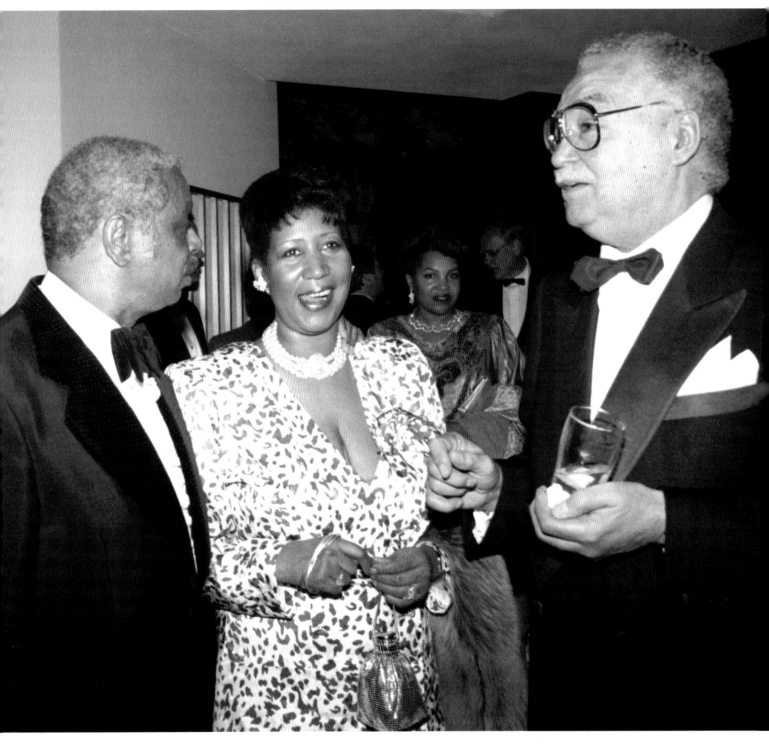

Aretha with Judge Damon J. Keith (LEFT) and Mayor Coleman A. Young at the Renaissance Center.

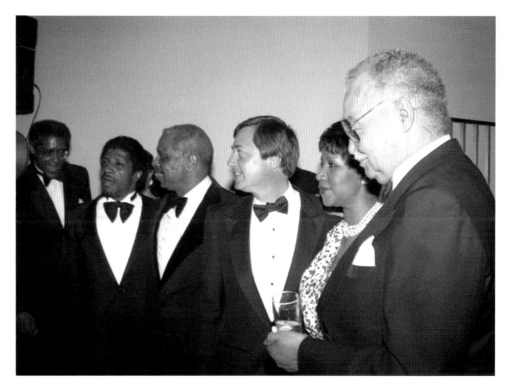

Attorney Ken Cockrel Sr., Reverend Cecil Franklin, Judge Damon J. Keith, Governor Jim Blanchard, Aretha, Mayor Coleman A. Young (LEFT TO RIGHT).

19
—
86

JANUARY

Live Backstage at the American Music Awards

A retha appeared on the American Music Awards live via satellite from the Premier Center in Sterling Heights, Michigan, to perform and receive two awards. Two production crews, one from Los Angeles–based Dick Clark Productions and the other from WXYZ ABC in Detroit, started their work on the set at 6:00 a.m. for the 8:00 p.m. live telecast.

As she waited for the awards to be announced, Aretha was backstage in her dressing room with her son Teddy, brother Cecil, and sister-in-law Earline. Aretha had changed into a white sequined mini and was relaxing on the velvet sofa barefoot while listening for cues from the Los Angeles director. She won awards for Female Video Artist Soul/R&B and Female Artist Soul/R&B. When she accepted her second award, she tried to hold back her tears, saying, "I would like to accept it in memory of my dad, Reverend C. L. Franklin." Her 1986 appearance would be the last time she was on the AMAs.

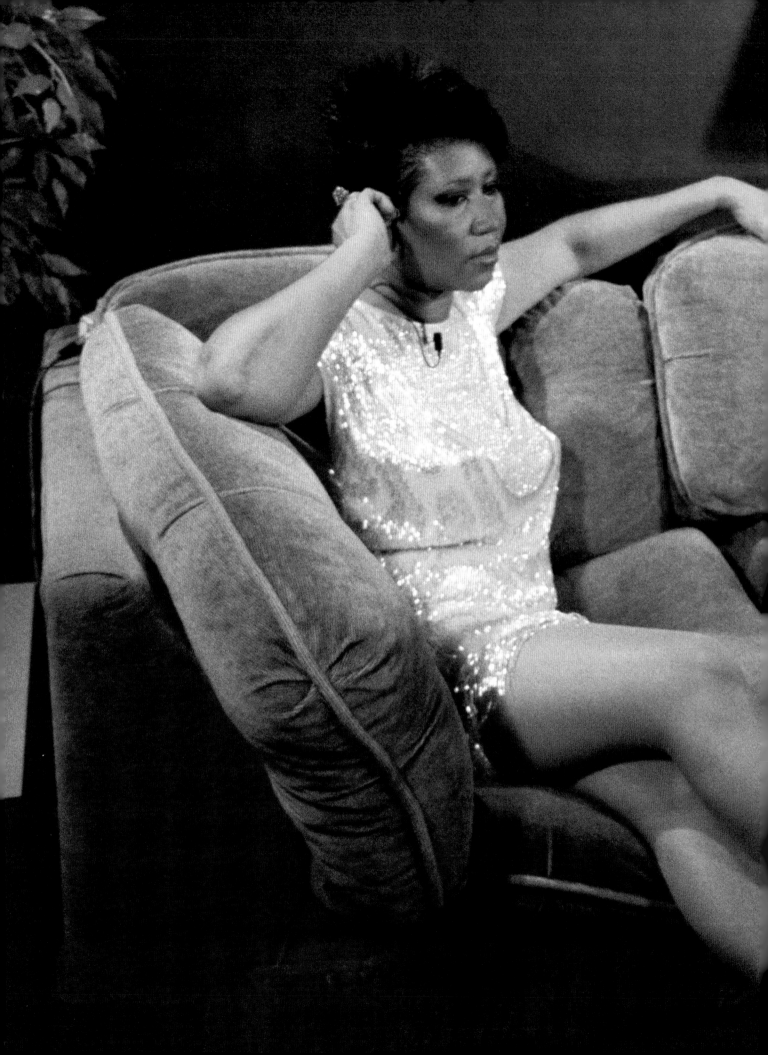

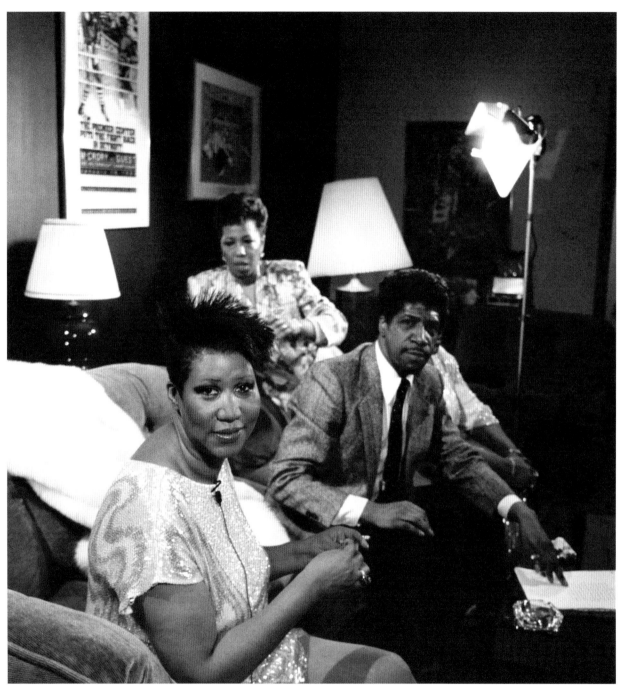

Backstage with her brother, Cecil, and sister-in-law Earline.

When she was introduced via satellite by
Diana Ross, Aretha was dressed in a Bill
Blass gown with matching jacket (RIGHT).

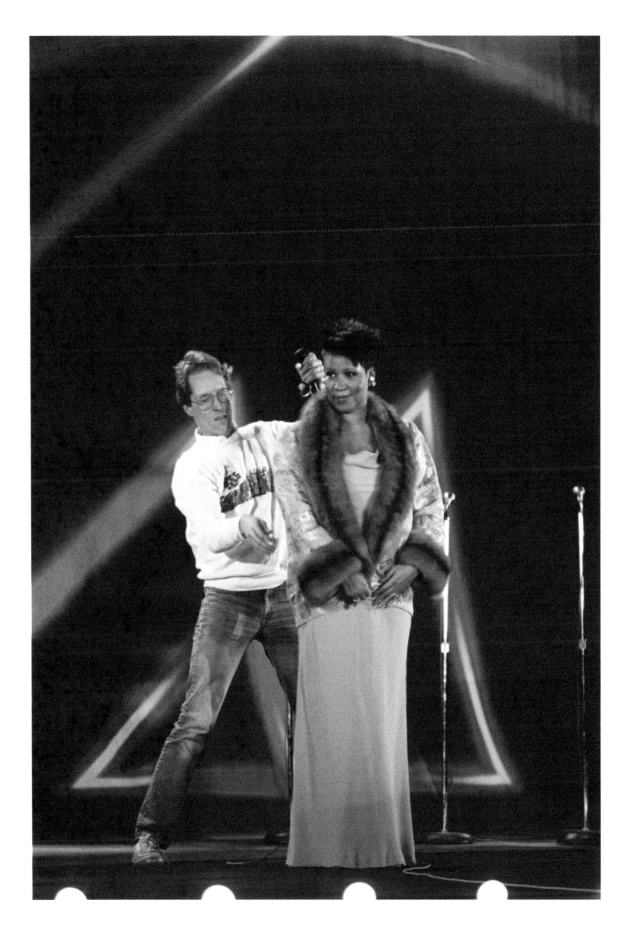

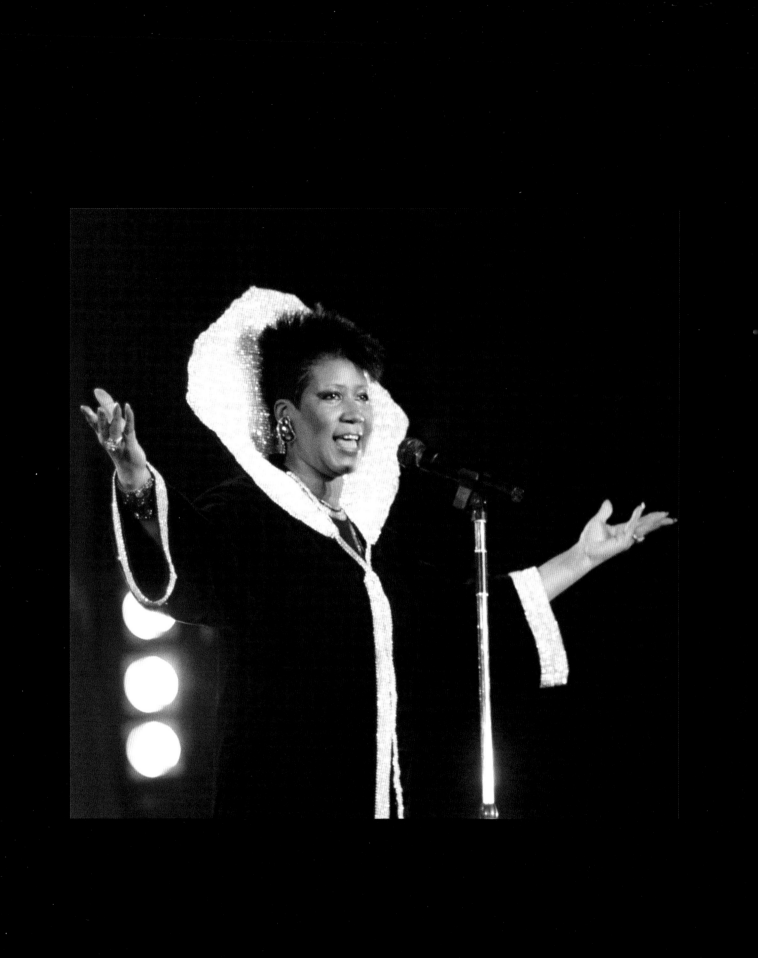

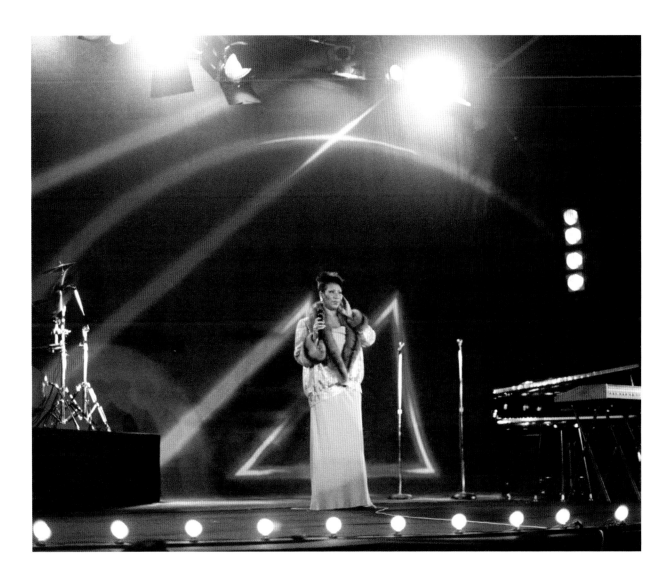

As she sang "Another Night," Aretha wore a
black velvet coat with an eight-pound rhinestone
collar designed by James Cape of Detroit (LEFT).

Aretha with her son, Teddy White, left, and Barry Glazier, of Dick Clark's staff.

In these exclusive photos, Aretha Franklin hosts a backstage Premier Center party before the "American Music Awards."

Detroit singer Ortheia Barnes, center, joined regulars Brenda Corbett, left, and Margaret Branch in backing Aretha for her number on the awards show.

Director picks Aretha over Madonna

Click!
Linda Solomon

FLASH!
"Though I was asked to go to Hong Kong to direct **Madonna,** I elected instead to come to Detroit to work with Aretha," said director **Barry Glazier** of Dick Clark Productions, the producers of the *American Music Awards.* **Aretha Franklin** performed and received two awards via satellite at the Premier Center in Sterling Heights. The staffs from L.A.-based Clark Productions, ABC and WXYZ started work on the set at 6 a.m for the 8 p.m. live telecast.

and her talented husband, producer **Michael Krauss,** a former Detroiter. Also at the table were Mike's vivacious mother, **Joie,** a local resident, and his brother, **Perry,** of Los Angeles. After lunch, Joan autographed covers of her new videocassette *Your New Born Baby* at Oakland Mall's B. Dalton Bookstore. It's an "all in the talented family" work produced by Michael and distributed by Perry ...
Nationally known UCLA physician **Dr. Robert Simon,** founder of International Medical Corps,

Dr. Seymour Ziegelman, left, and Aretha's brother, the Rev. Cecil Franklin, and his wife, Earline.

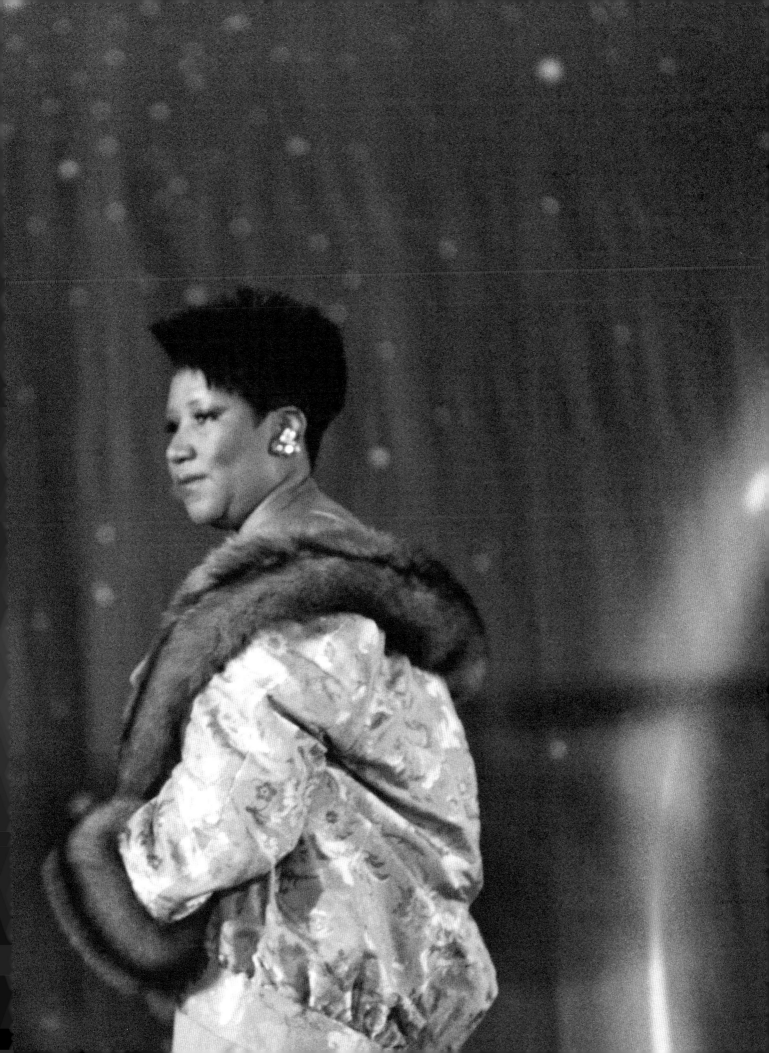

19
—
86

FEBRUARY

Pink Cadillac

———

In the nationally televised Amoco commercial, Aretha fills up her pink Cadillac with gas and drives off. Despite the Manhattan cityscape, which was brought in from *Ghostbusters* for background, the spot filmed at Combermere studio in Troy, Michigan. Aretha is showcased in a custom-painted pink Cadillac convertible with R E S P E C T on the license plate.

Pink would become her signature color. She featured it on party invitations and in party decor. Pink Cadillacs were even featured on her forty-ninth birthday cake. It was very special for me to photograph Aretha with an iconic pink Cadillac that she made famous in "Freeway of Love."

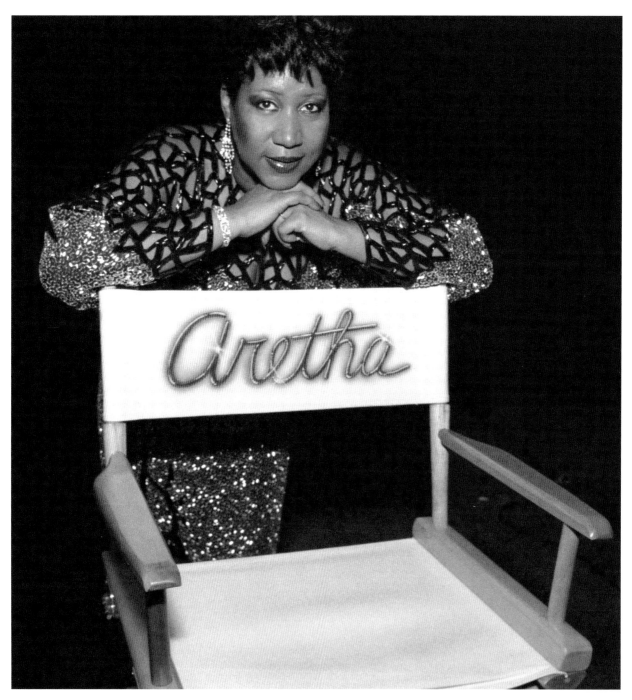

Aretha relaxed between takes in a director's chair with her name in signature pink.

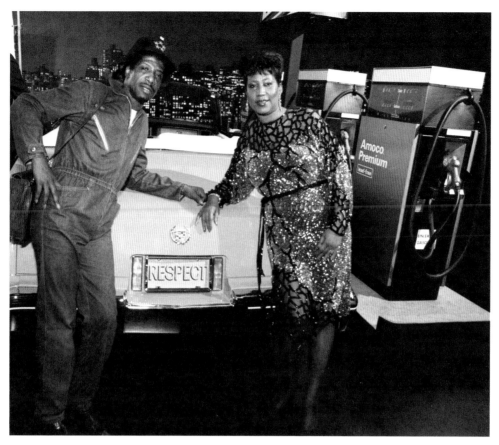

Aretha and her brother, Cecil.

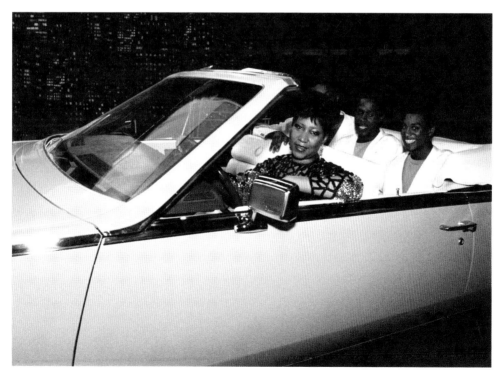

Aretha with actors in the commercial.

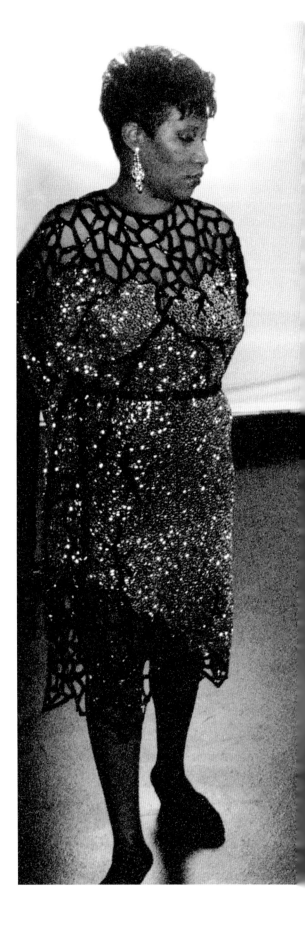

I have often wondered what
Aretha was thinking here, as
she appears deep in thought.

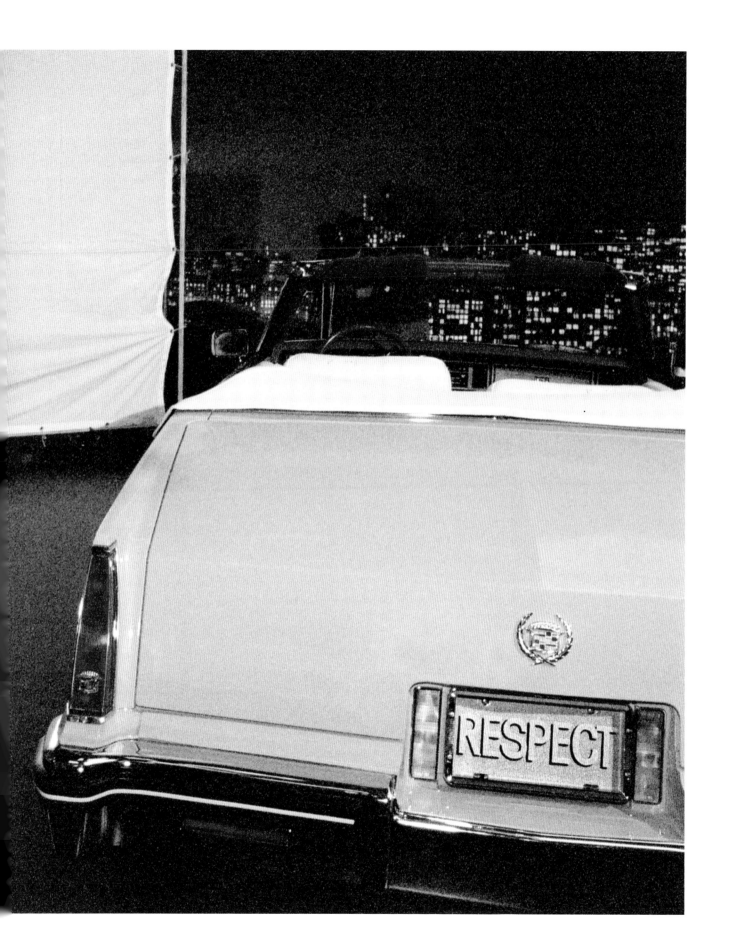

19
—
86

MAY

Aretha, *Showtime Special*

———

*A*retha was filmed at Detroit's Music Hall Center for the Performing Arts with the Franklin family in the audience, of course. Aretha introduced her son Teddy, congratulating him on graduating from college and saying that she was a "proud mama." The hour-long Showtime cable special features Aretha with a twenty-four-piece orchestra and a gospel segment with the sixty-five-member choir from the St. James Baptist Church in Detroit. Saxophonist Clarence Clemons (the Big Man) from Bruce Springsteen's E Street Band was featured too.

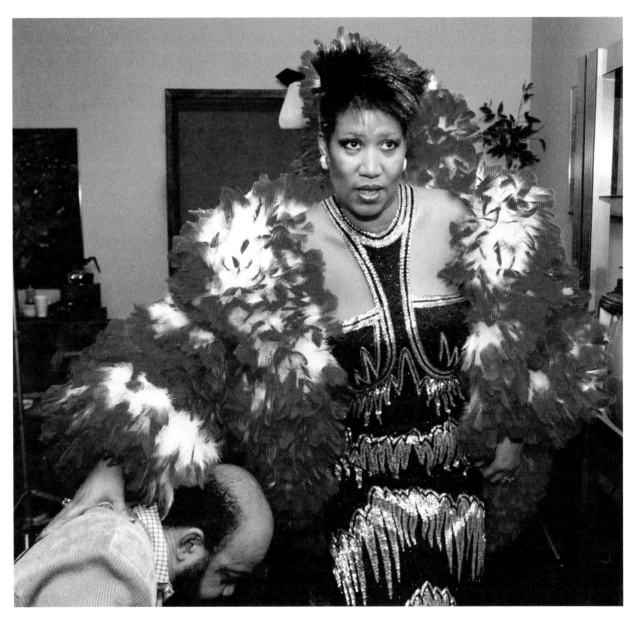

Backstage.

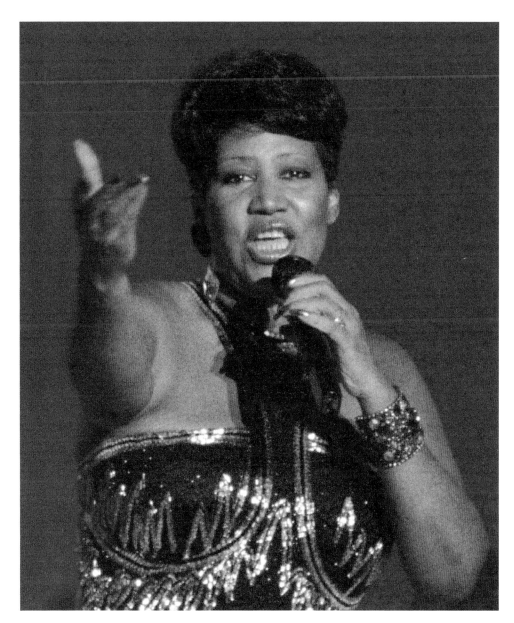

Rehearsing.

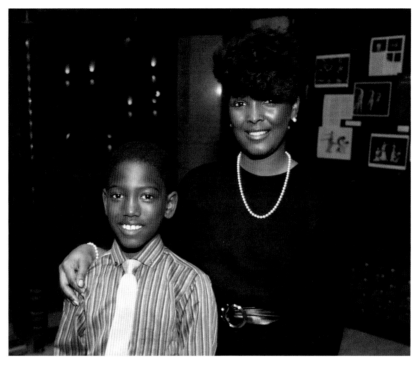

Aretha's niece Sabrina Vonne' Owens and her son LaRone in the
lobby of the Music Hall Center for the Performing Arts in Detroit.

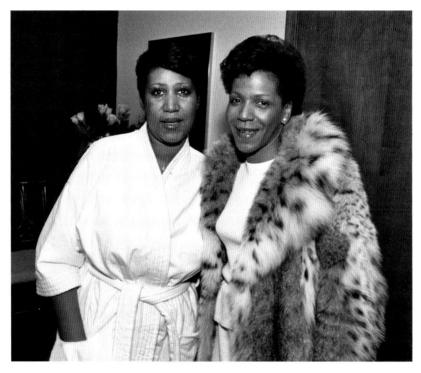

Backstage with Aretha and Aretha's younger sister, Carolyn, who
wrote "Angel," one of the songs Aretha highlighted.

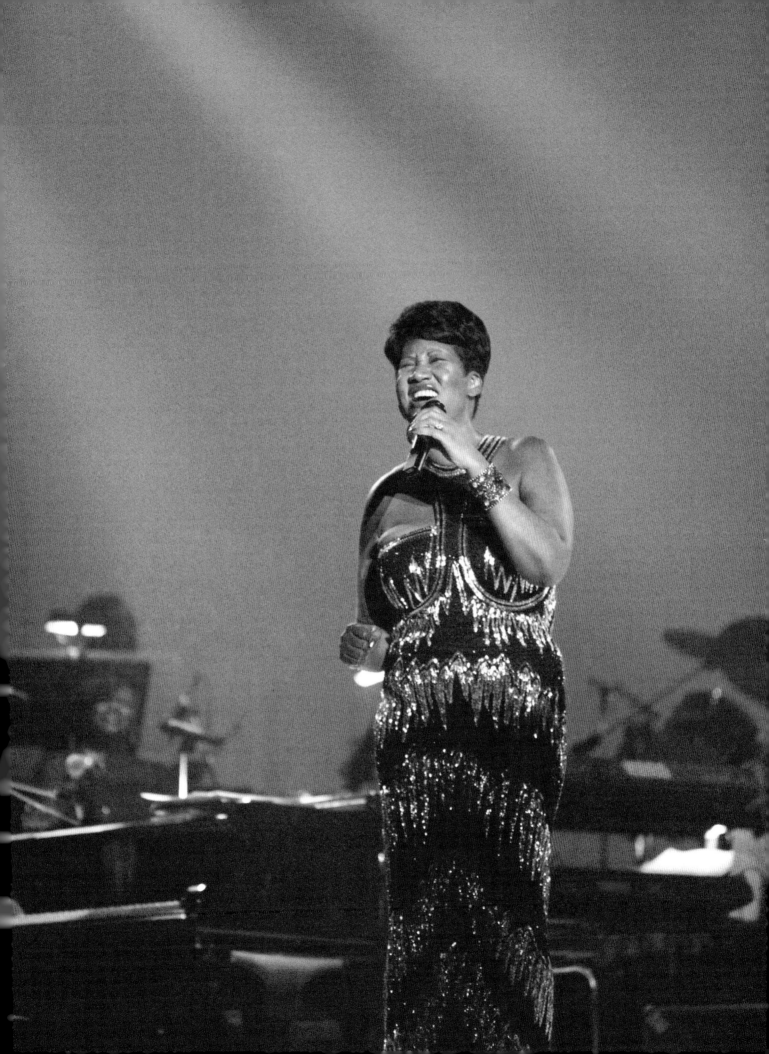

19
–
86
JUNE

College Graduation Party

I was thrilled Aretha invited me to the celebration for her son's college graduation from Michigan State University. Aretha was a very proud mom. She decorated each room of her home with green-and-white MSU streamers and banners to show pride for her Teddy. She catered the celebration for sixty-five guests with a delicious buffet of sliced tenderloin, barbecued chicken, and pasta. Crystal punch bowls were filled with healthy fruit juices only, no alcohol. Teddy enjoyed "riding on the freeway" in his new graduation gift from his mom.

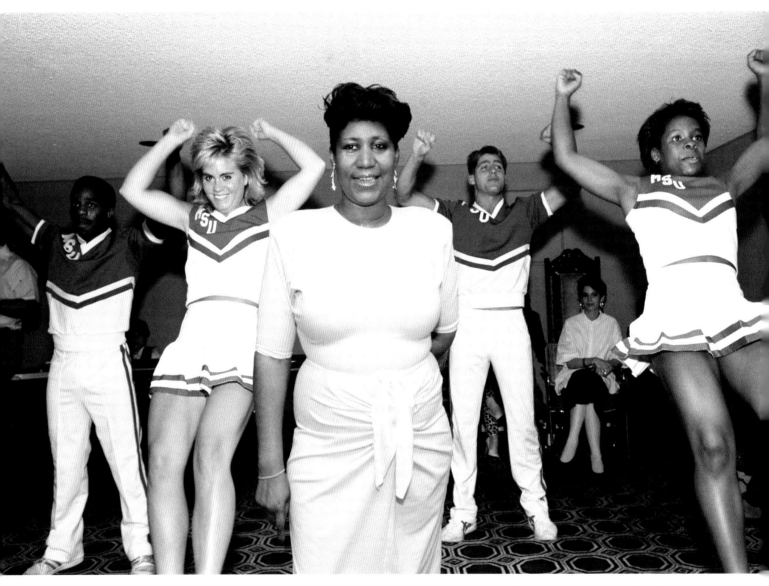

Aretha surprised Teddy's guests by inviting the Michigan State University cheerleading squad to her home.

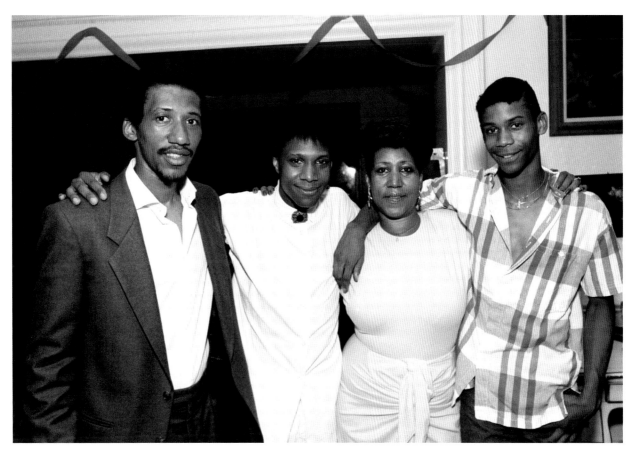

Aretha with sons (FROM LEFT TO RIGHT) Eddie Franklin (28), Teddy Richards (22), and Kecalf Cunningham (16).

While Teddy's guests danced to his mom's hit "Who's Zoomin' Who?" downstairs, his mom quietly relaxed to a Sade album upstairs.

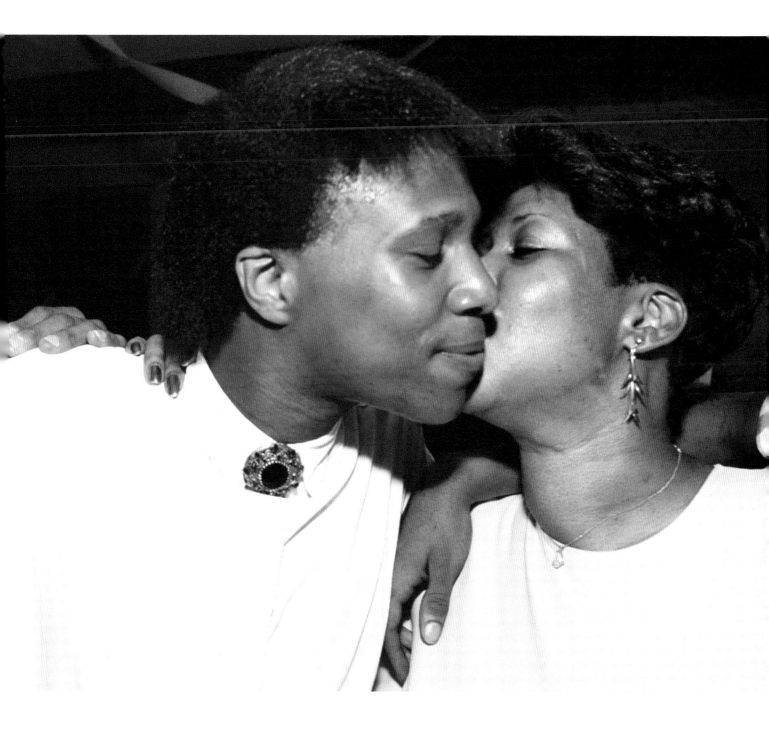

19
—
86

JULY

Aretha and the Rolling Stones

Yes! This is Aretha!

She arrived at United Sound Systems studios in Detroit in her Cadillac limousine to film the music video for "Jumpin' Jack Flash." When she came out, I was stunned to see her new style—one she personally selected with her gal pals.

The regal Queen of Soul had purple punk spiked hair and a funky ponytail and was wearing a tiger-striped knee-length jumpsuit, a metallic gold leather coat, and mannequin sunglasses.

Keith Richards and Ronnie Wood of the Rolling Stones traveled to Detroit to film the music video, which Richards produced. Wood played guitar and Richards, lead guitar. Aretha played keyboards. Her cousins Brenda Corbett and Margaret Branch were joined by her pal Ortheia Barnes as backup vocals. Clarence Clemons played sax. The song was featured on Aretha's album *Aretha* and is the title track for the Whoopi Goldberg film titled—what else?—*Jumpin' Jack Flash*.

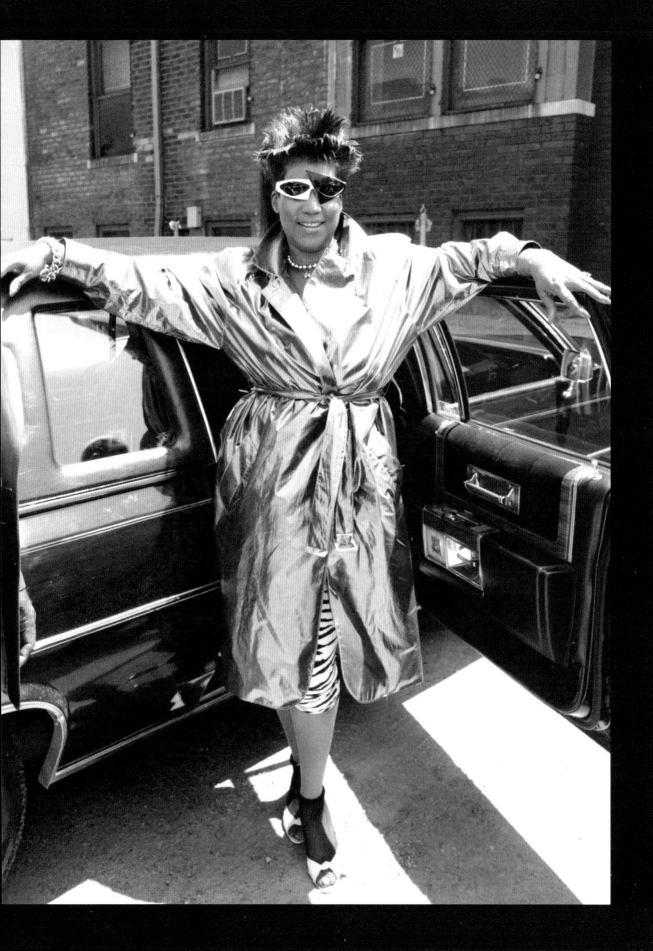

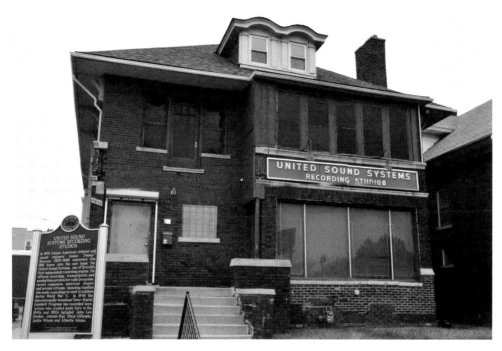

The United Sound Systems, the studio where Berry Gordy Jr. recorded before opening his Motown recording studio. Miles Davis and Jackie Wilson are among the major stars along with Aretha Franklin who recorded here.

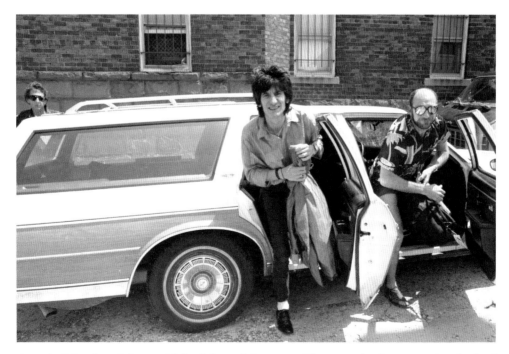

Ronnie Wood arriving at United Sound Systems. This was the first time Aretha had met Wood and Richards.

Whoopi arrived incognito, covered in blankets, in the boot of a station wagon.

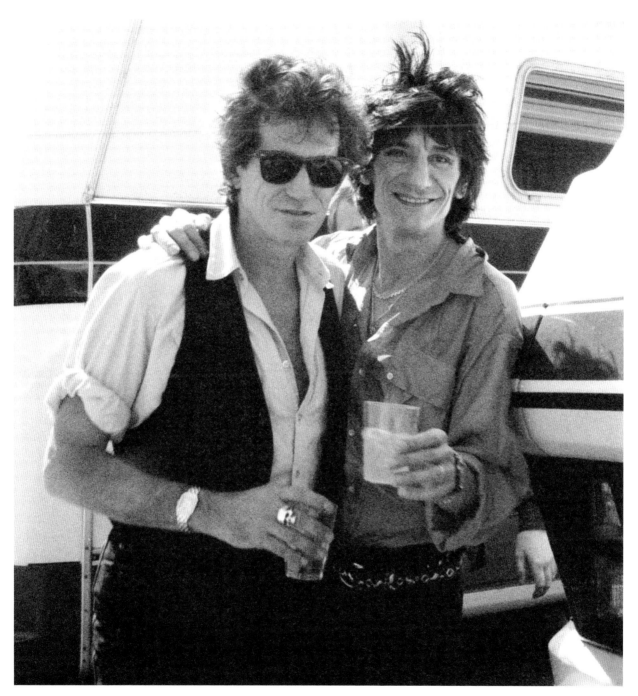

Keith Richards and Ronnie Wood.

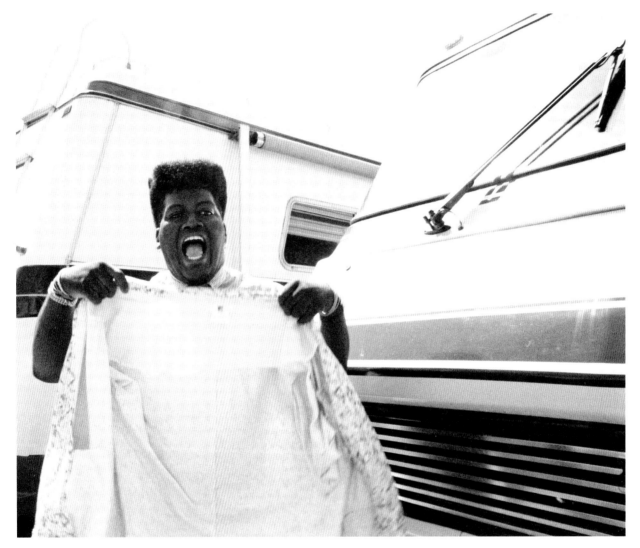

Saxophonist Clarence Clemons from Bruce Springsteen's E Street Band.

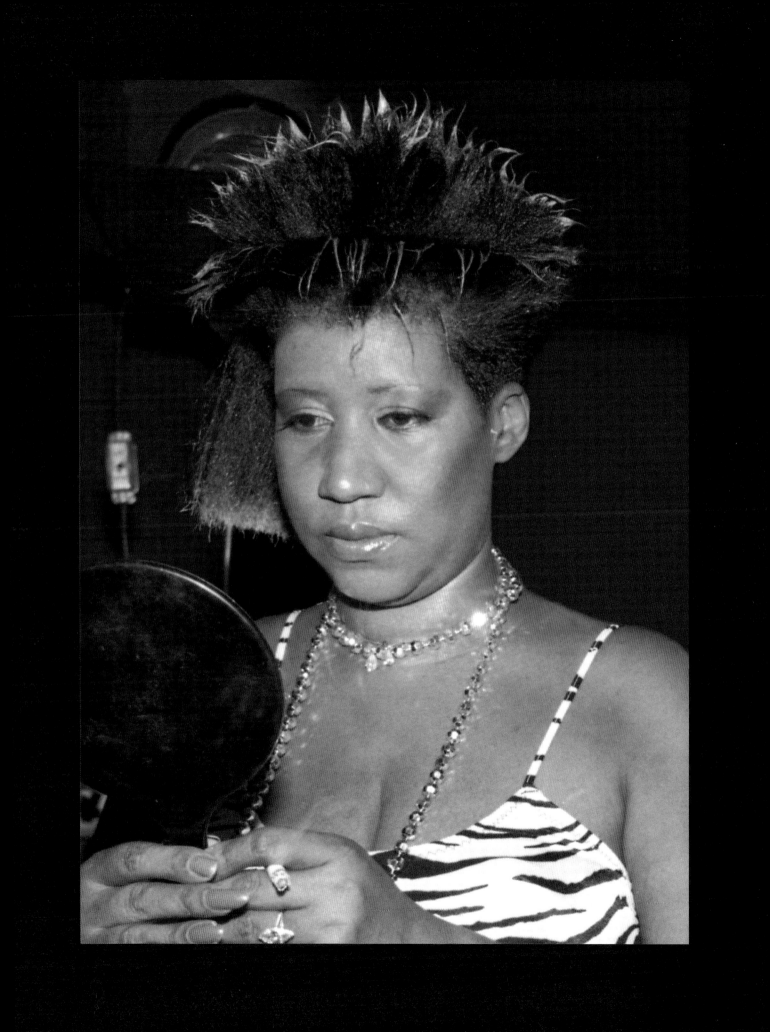

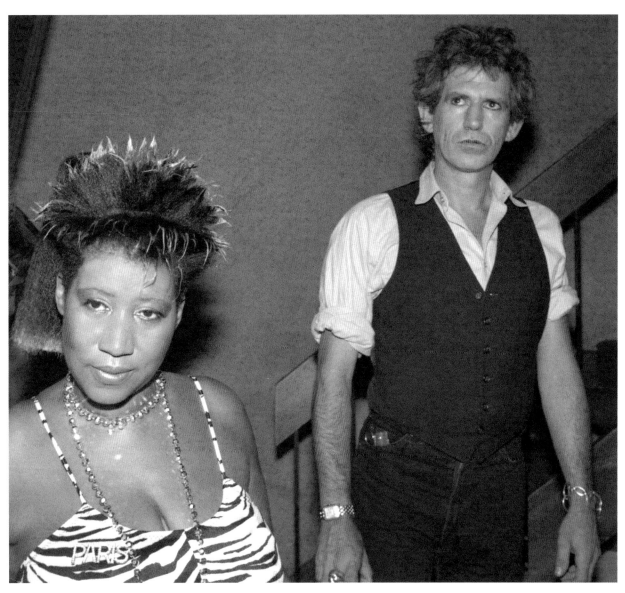

Aretha and Keith Richards.

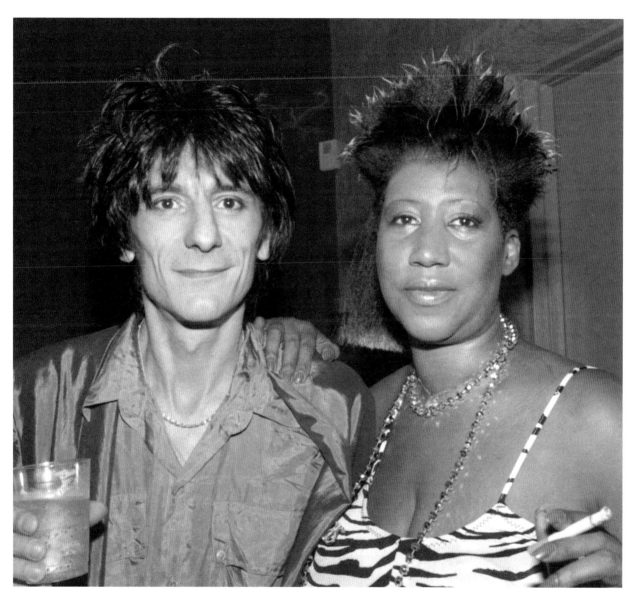

Aretha and Ronnie Wood.

19
—
86

NOVEMBER

Honored by the United Negro College Fund

————

It wasn't just "another night" at the Omni/Millender Center in downtown Detroit. Aretha was honored in a star-studded tribute to benefit the United Negro College Fund. She is a contributor, and education is very important to Aretha and the Franklin family. The black-tie gala took place in the tiered atrium with a special theater designed specifically for Aretha's tribute. Her close friends the Spinners were there to celebrate and honor her.

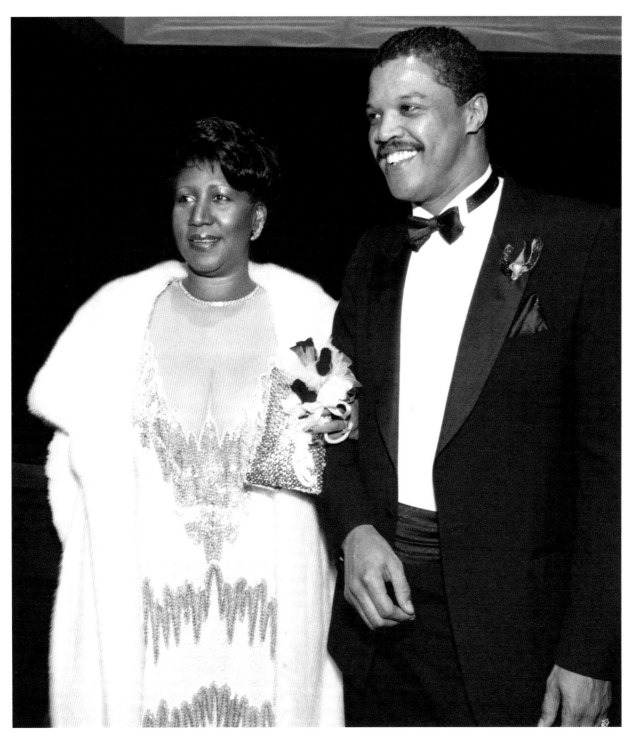

Aretha with Willie Wilkerson.

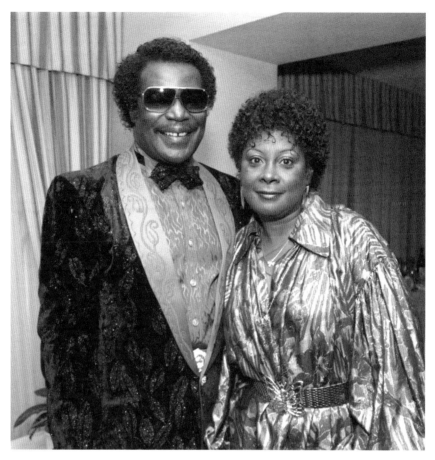

Pervis Jackson of the Spinners with his wife, Claudreen Jackson.

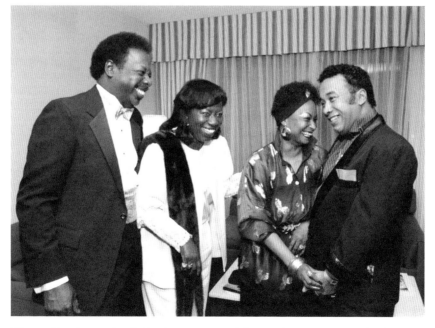

Henry Fambrough of the Spinners with his wife, Norma, and Billy Henderson of the Spinners and his wife, Barbara.

19
—
87

JANUARY

The Queen of Soul and the Godfather of Soul!

———

For the first time in their careers, the Queen of Soul and the Godfather of Soul performed together, and it happened in Detroit. The musically historic event was a concert film and live album recorded at Club Taboo in Detroit. *A Soul Session: James Brown and Friends* aired internationally on HBO/Cinemax, and the "friends" included Robert Palmer, Wilson Pickett, Joe Cocker, Billy Vera, and Dan Hartman. The producers of the concert film wanted the Queen of Soul to appear with the Godfather of Soul, and they knew if Aretha said "yes" it would have to take place in Detroit. And it did.

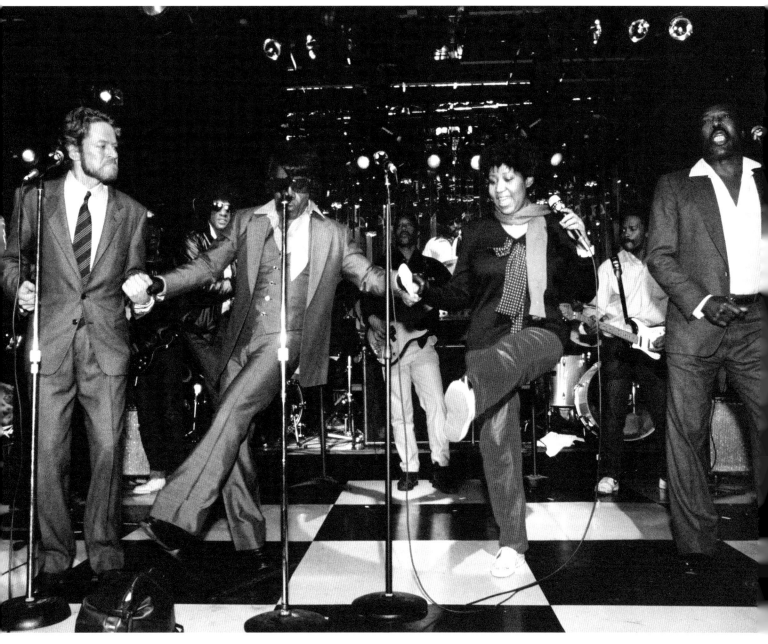

Aretha in her sneakers rehearsing the James Brown hit "Living in America" with Robert Palmer, Wilson Pickett, and the Godfather of Soul James Brown.

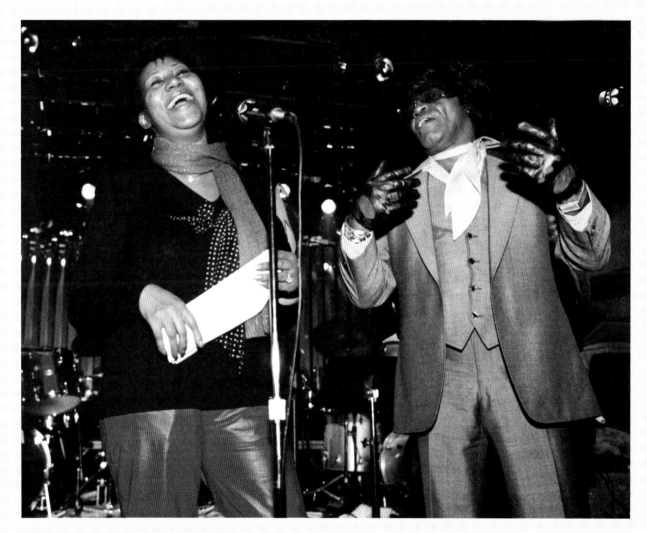

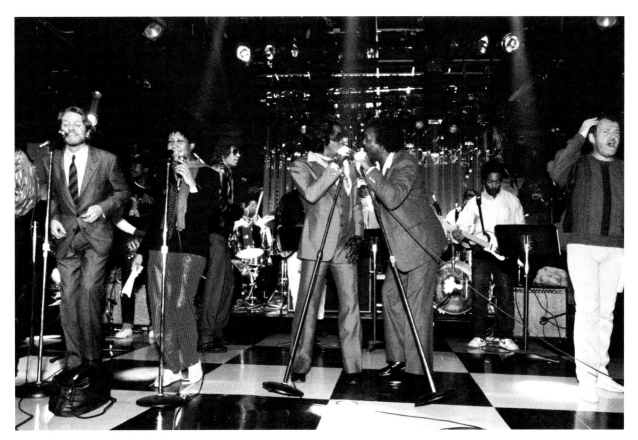

Aretha rehearsing with Robert Palmer, James Brown, Wilson Pickett, and Joe Cocker.

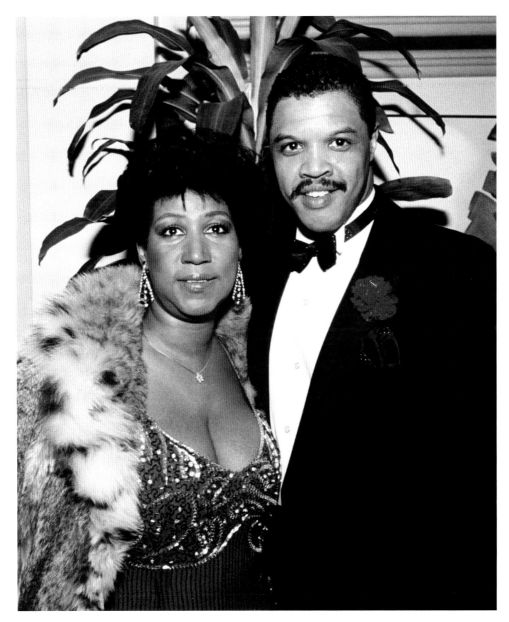

Backstage with Aretha and Willie Wilkerson.

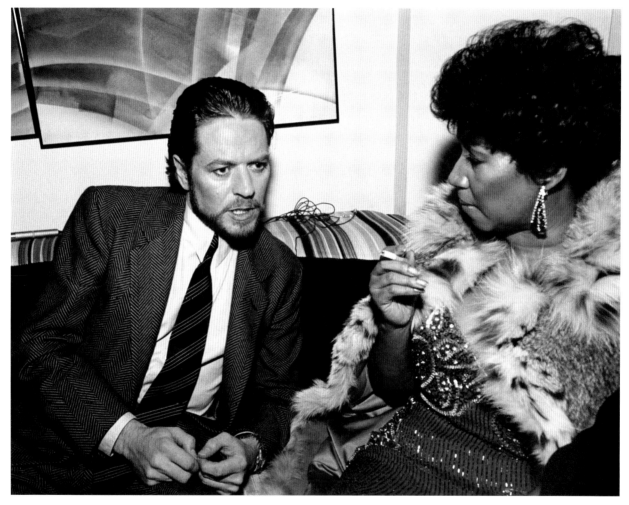

Robert Palmer with Aretha.

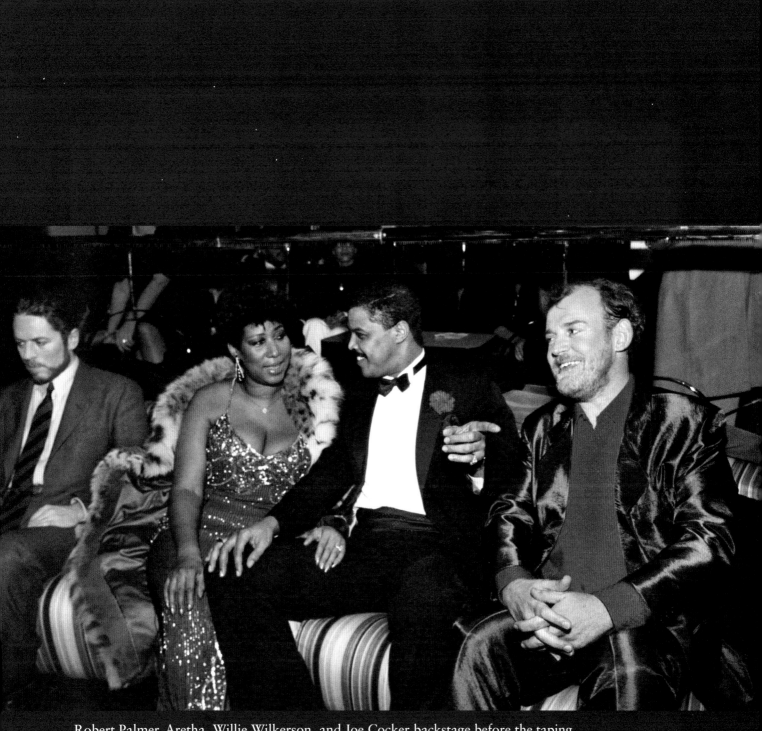

Robert Palmer, Aretha, Willie Wilkerson, and Joe Cocker backstage before the taping.

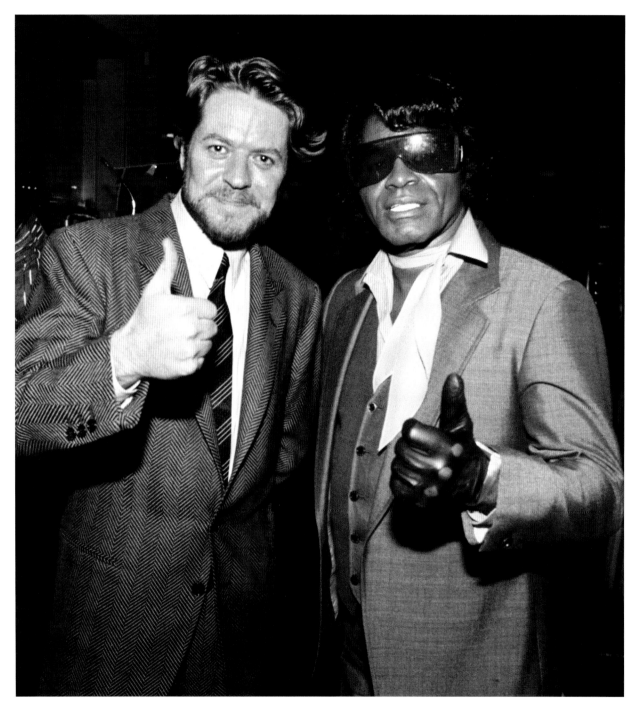

Robert Palmer and James Brown.

Joe Cocker backstage.

19

87

JULY

Aretha's Hope

———

On a perfect summer night in Michigan, Aretha hosted a black-tie campaign party at her home for Reverend Jesse Jackson's 1988 presidential campaign. She invited a few hundred guests to her home to meet Aretha's choice for the Democratic presidential nomination. Aretha and Reverend Jackson had met when they were teenagers, and he was one of her oldest and closest friends. Jackson greatly admired her father and considered Reverend C. L. Franklin his mentor.

Ta-da! Here's Aretha!
On her front lawn before
the party begins to make
sure everything is perfect.

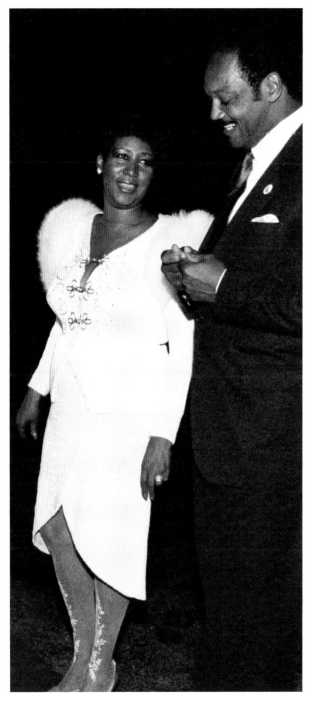

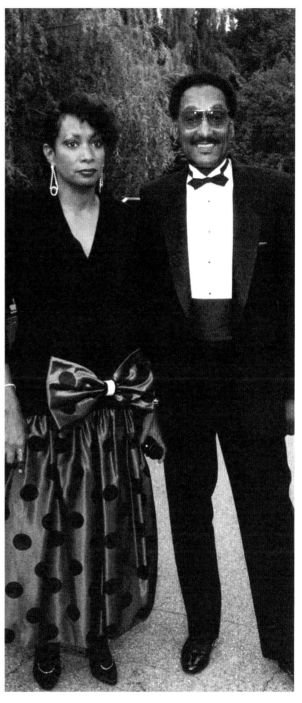

Aretha and Reverend Jesse Jackson.

Abdul "Duke" Fakir of the Four Tops with his
wife, Piper. Duke called Aretha "little sis."

19
—
87

JULY

New Bethel Baptist Church Live Recording

*O*ne Lord, One Faith, One Baptism was recorded live on three hot summer days in Detroit. "For years, people have been asking me to record gospel again," said Aretha, "so I decided it was time. These are the songs I loved as a child singing in the choir." This historic album featured Aretha, her sisters, Erma and Carolyn, and their cousin Brenda Corbett singing the songs they loved as children in church. Cecil was an orator on the album.

"I am feeling sad and glad. This was my father's church and you can feel him when you are here," said Erma Franklin. "This is my home," Aretha said. Her late father, Reverend C. L. Franklin, had been the pastor. "This is where it all started for her," said Pastor Robert Smith Jr., who has been the Pastor of New Bethel Baptist Church since Reverend C. L. Franklin's passing in 1984.

Ticket information was publicized, but the recording sessions were free for all of Aretha's fans, friends, and church family. Close to four thousand people filled New Bethel Baptist Church for the three days of recording. The collection plate was passed, and thousands of dollars were raised to feed the homeless in Detroit and for Children's Hospital of Michigan in Detroit.

One Lord, One Faith, One Baptism was very important to Aretha. The album received a Grammy and was the last project with Erma and Carolyn singing together. Her younger sister, Carolyn, passed away from breast cancer in April 1988 at forty-three years old. Their brother, Cecil, passed away in December 1989 from lung cancer at forty-nine years old.

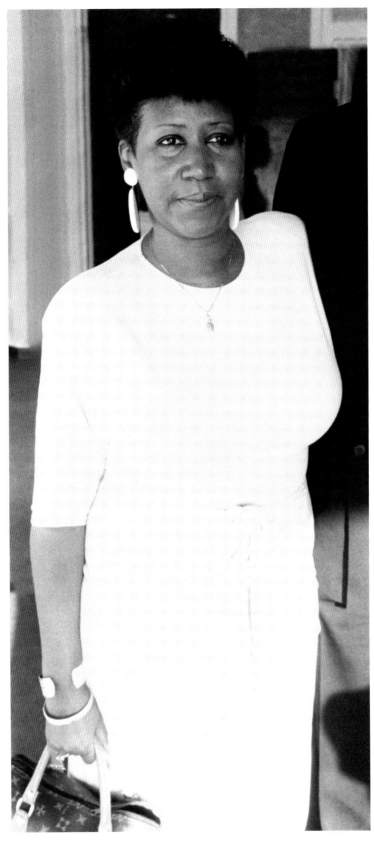

Arriving at New Bethel Baptist Church.

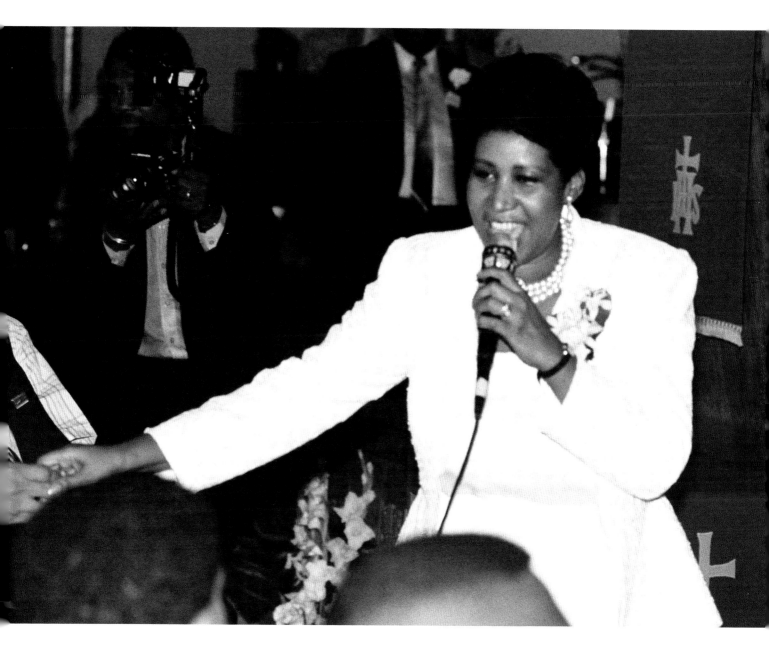

Aretha at the pulpit
and singing under the
portrait of her father.

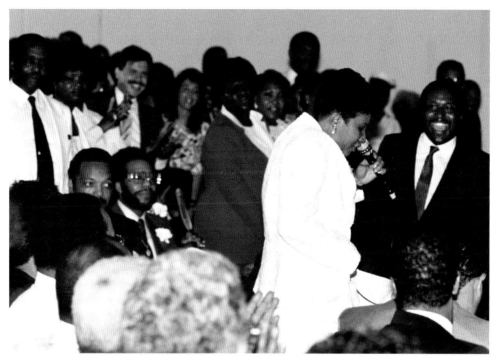

Aretha's closest friends and family were all there. To them she was "just Aretha."
Jesse Jackson was featured on the album and introduced segments of the program.
He referred to Aretha as "our sister beloved."

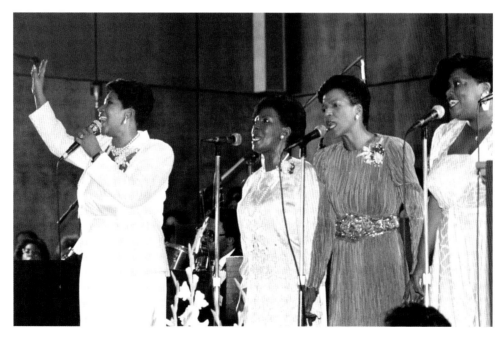

Aretha and her sisters, Erma and Carolyn, and cousin Brenda Corbett.

Aretha's signature designer
handbag is on the piano.

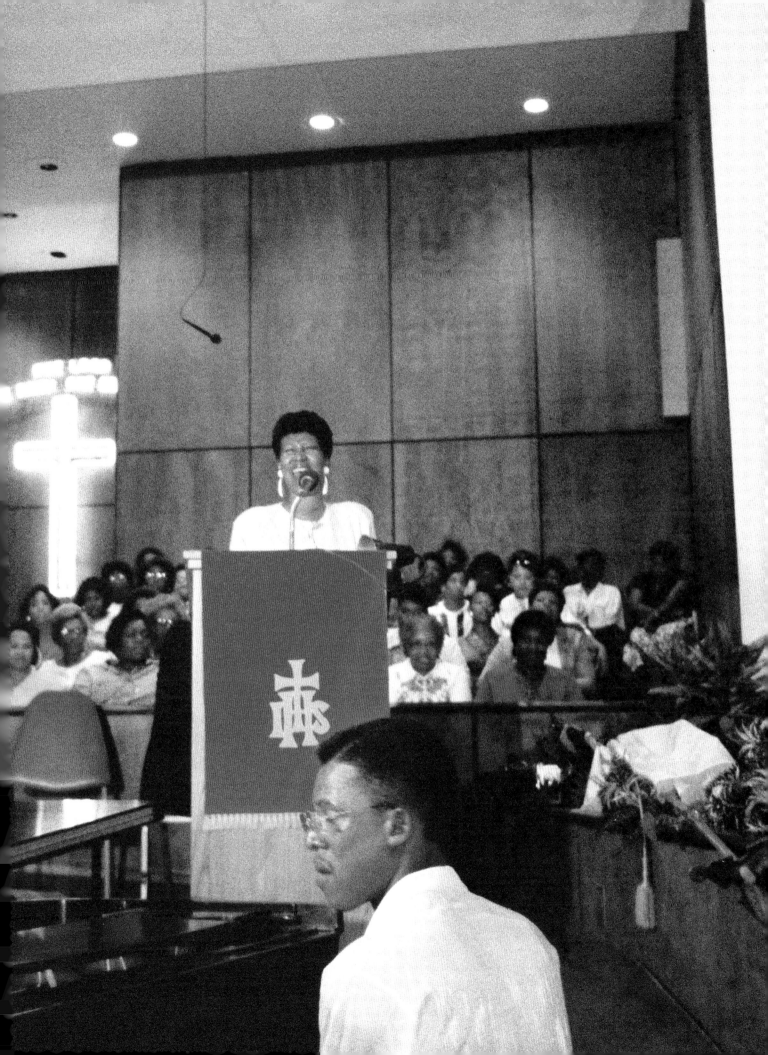

19
—
87

DECEMBER

Christmas at Home

———

Aretha's black-tie party was filled with music, laughter, and friendship as thirty guests enjoyed her home and company. The Queen's New Year's wish was "Peace for Detroit, peace throughout the world, and prosperity for everyone." At the end of the evening, she took off her Chanel shoes and relaxed, listening to Christmas music, including her favorite carol, "Hark! The Herald Angels Sing."

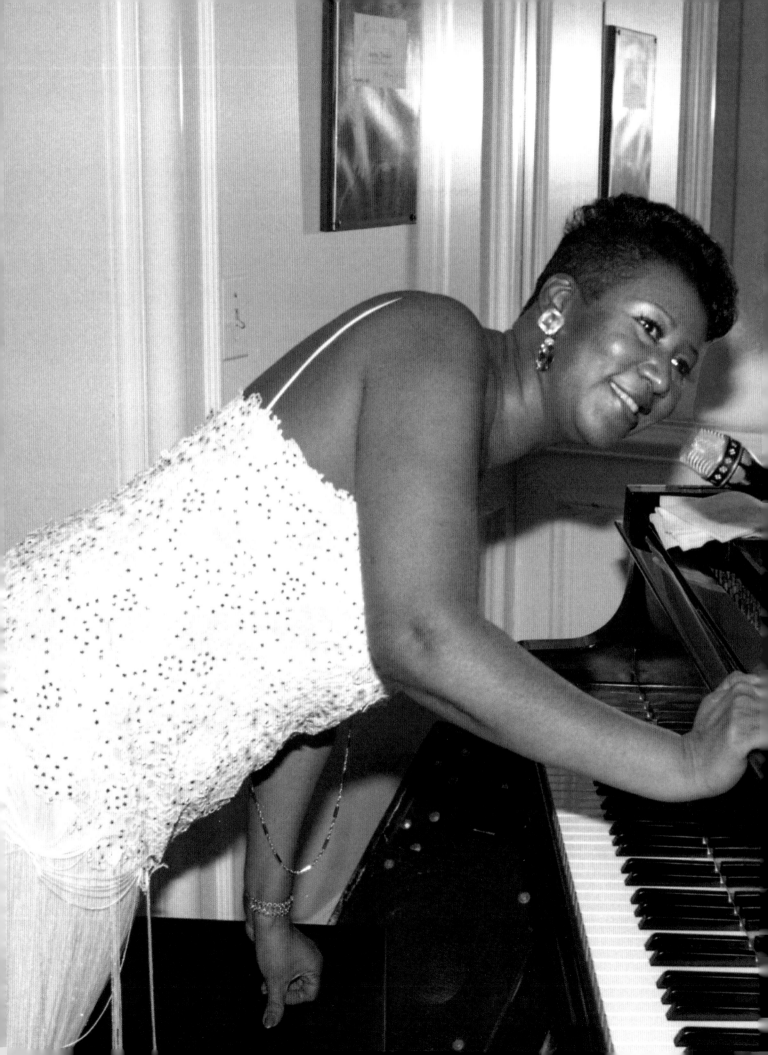

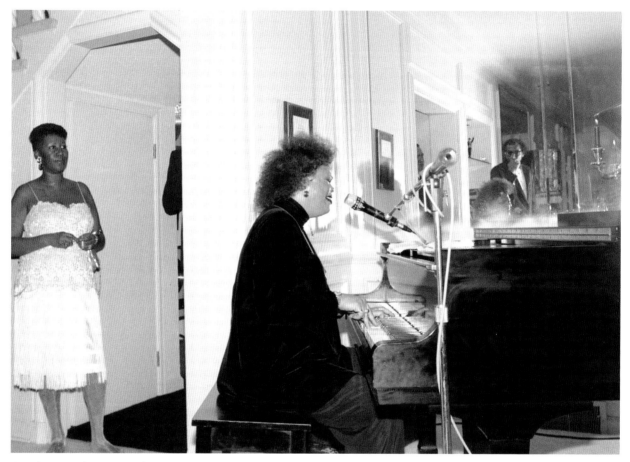

Aretha watching Brazilian jazz singer Tania Maria perform in her living room.

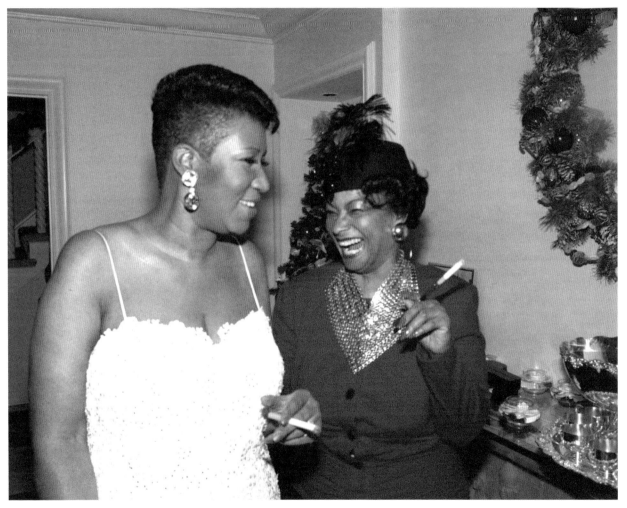

Aretha with her close pal Barbara Henderson.

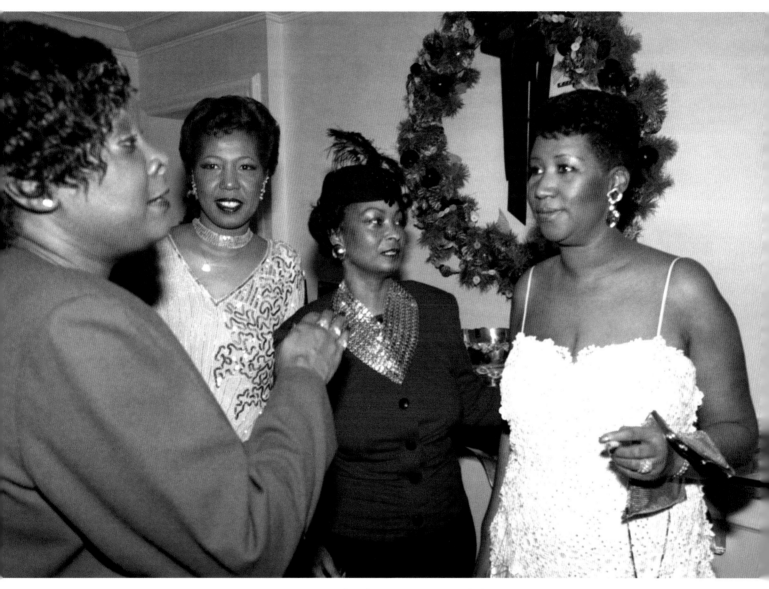

With Aretha on right, Claudreen Jackson (wife of Pervis Jackson of the Spinners), her sister-in-law Earline, and Barbara Henderson, wife of Billy Henderson of the Spinners.

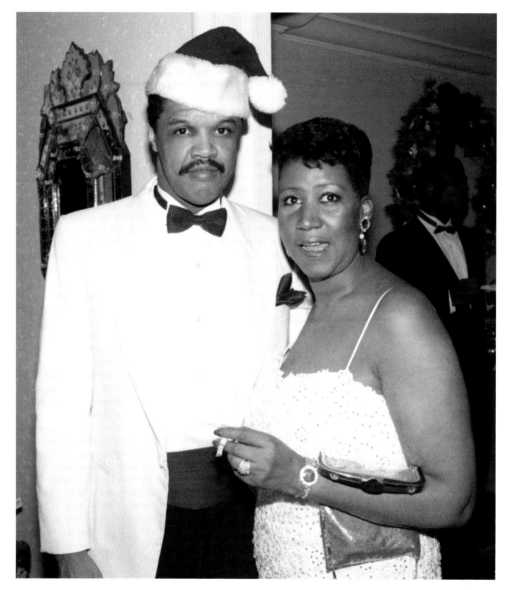

Aretha and Willie Wilkerson.

$$\frac{19}{88}$$

MARCH

Aretha's Message to Our Youth

─────────

As part of her commitment to young people of Detroit, Aretha participated in a public service announcement campaign against driving under the influence of drugs and alcohol. Her hit song "Think" was featured in the PSA titled *Think . . . Don't Drive with Drugs or Drink!*, which was funded by Dodge. "This is important to me because of the staggering statistics," she said. Aretha wanted to increase awareness in the United States about the tragic effects of drinking and driving.

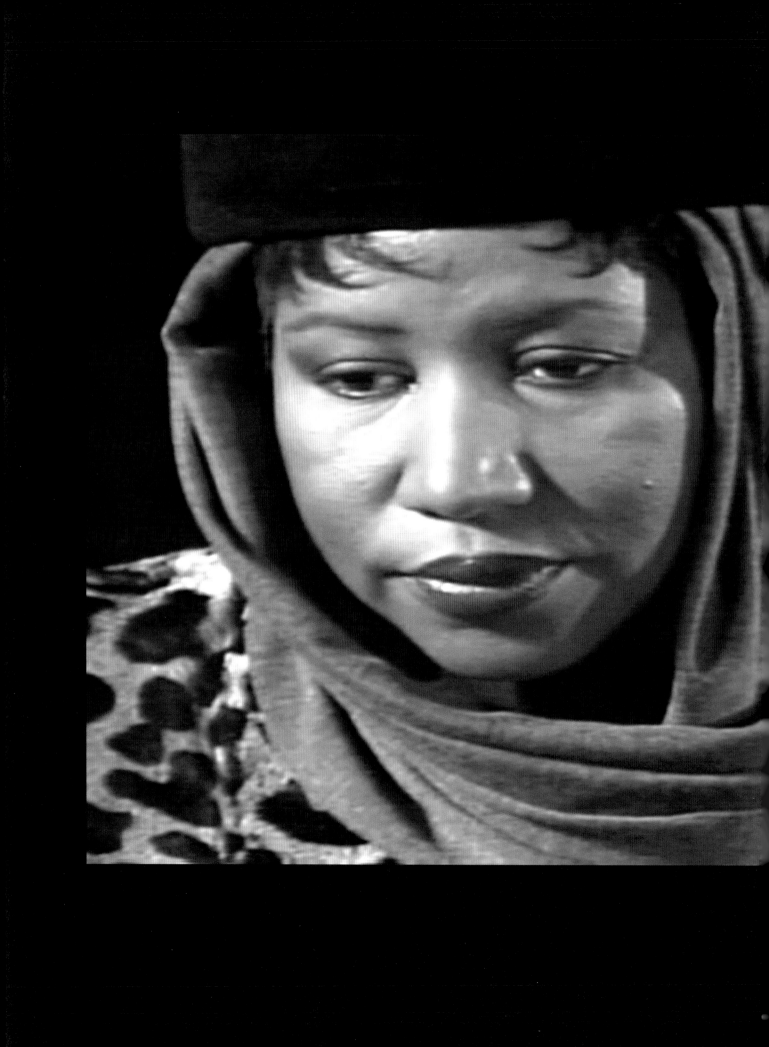

Announcing her campaign at the
Music Hall Center for the Performing
Arts in Detroit. "I am delighted to
be a part of such a positive program.
I will give it my best!"

19
–
88

JULY

A Queen's Masquerade Ball

————

Aretha *loved* giving parties, and I loved seeing the Queen of Soul as Queen Nefertiti, Aretha's favorite historical figure, at her wonderful masquerade ball. Aretha had a sculpture of Queen Nefertiti in her living room and became that queen at her ball. The party started when guests arrived and heard the Jimmy Wilkins Orchestra playing on her driveway. No ordinary band, this orchestra was in its own league. Frank Sinatra, Sarah Vaughn, Nancy Wilson, and Tony Bennett all performed with the Jimmy Wilkins Orchestra, and the Queen of Soul featured the fab big band at her home.

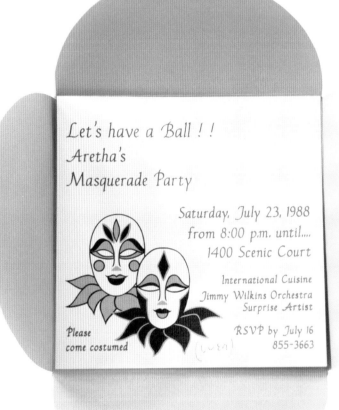

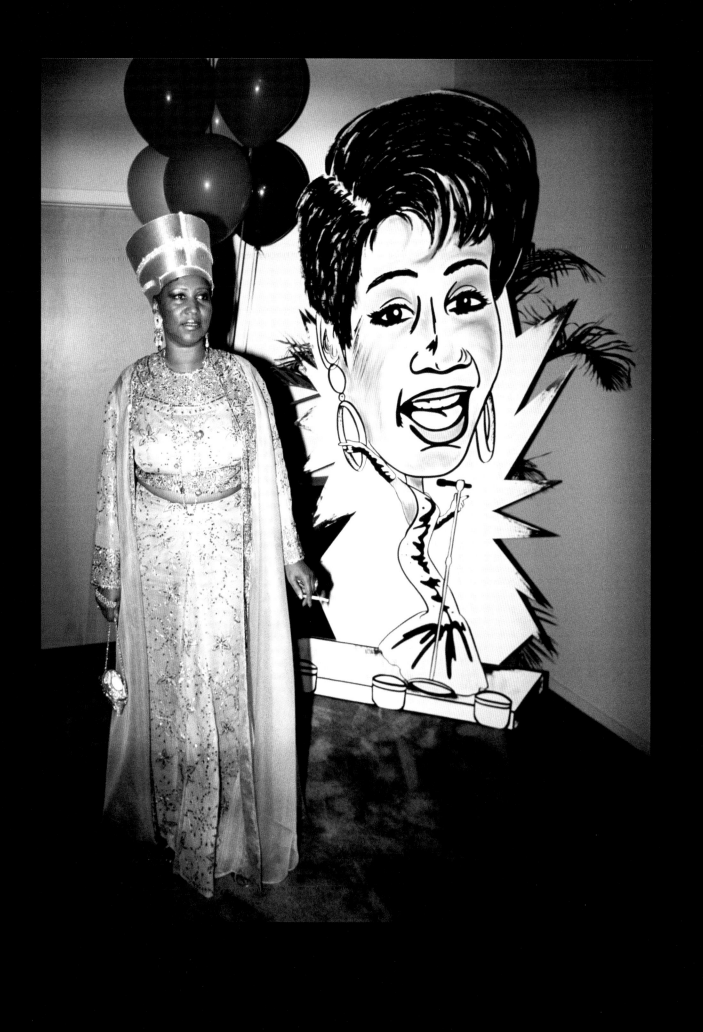

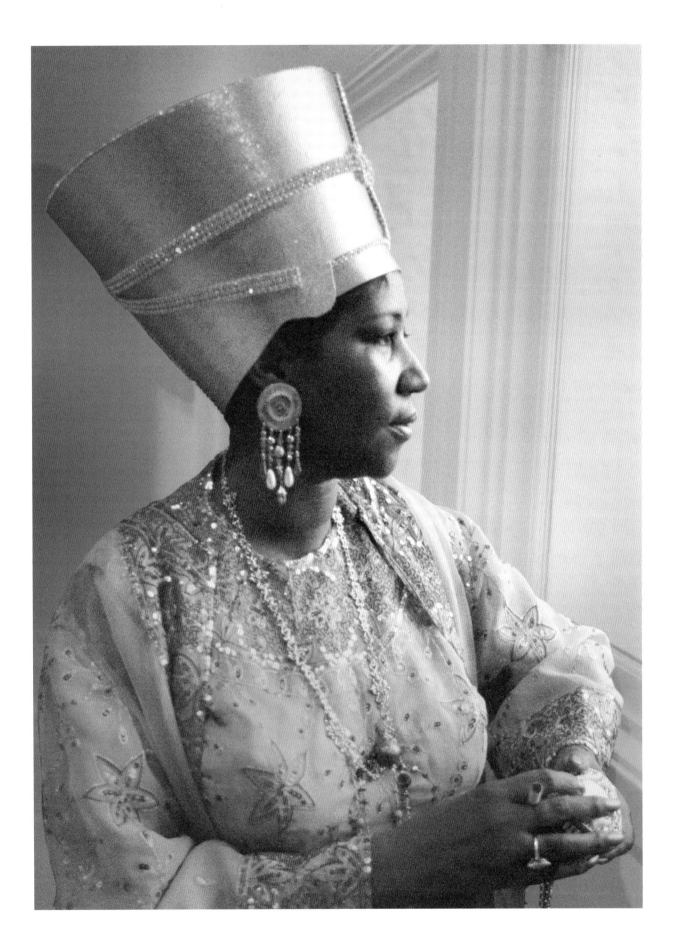

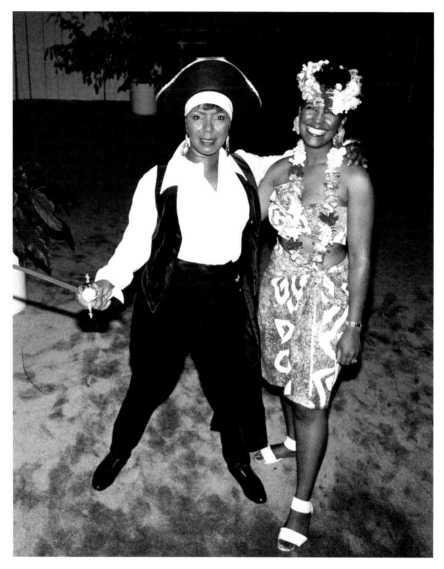

Erma Franklin and her daughter, Sabrina Vonne' Owens.

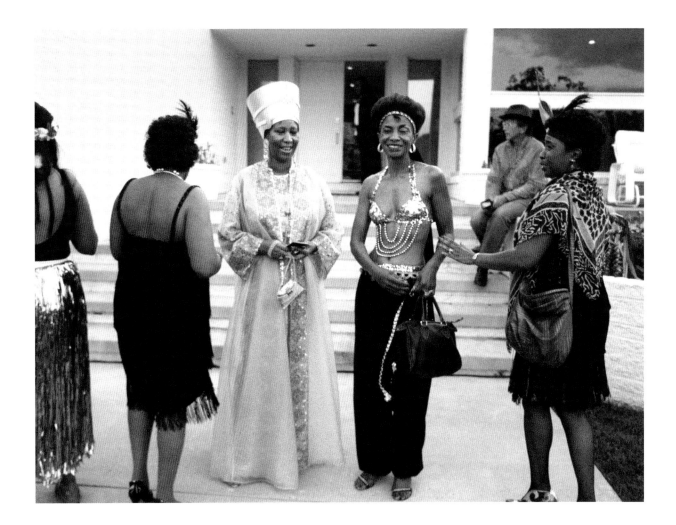

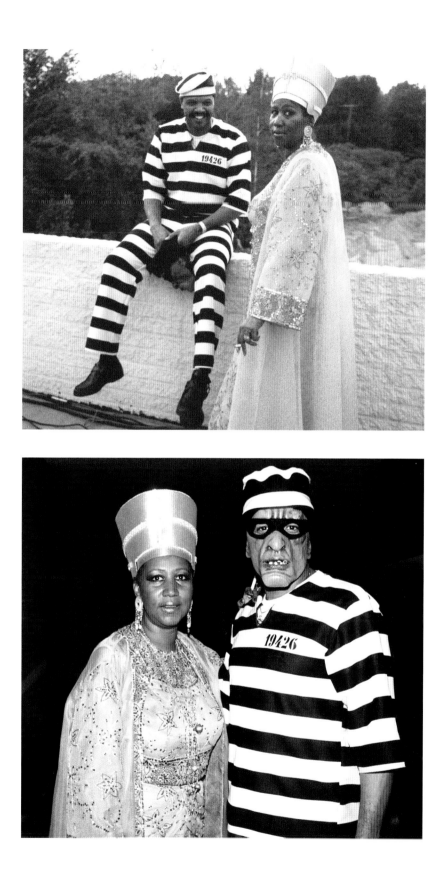

Detroit designer James Cape
brought models covered in
head-to-toe feathers.

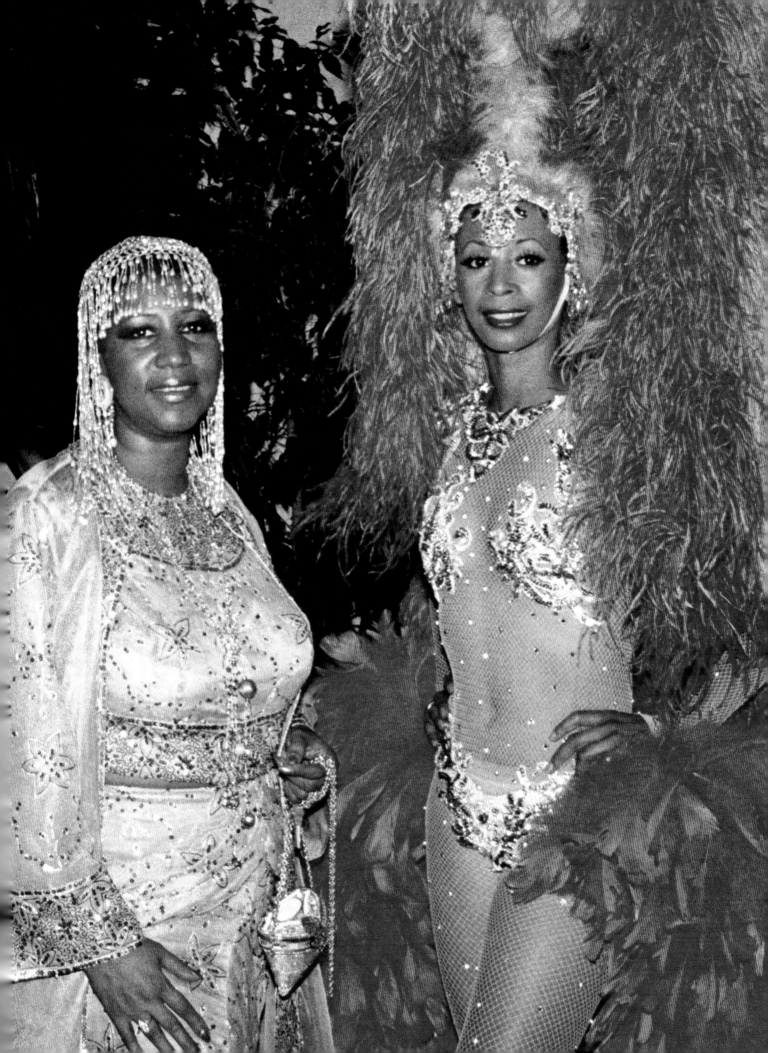

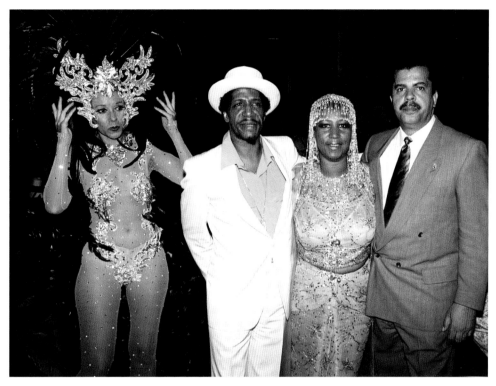

Aretha with her brother, Cecil, and Reverend Jim Holley.

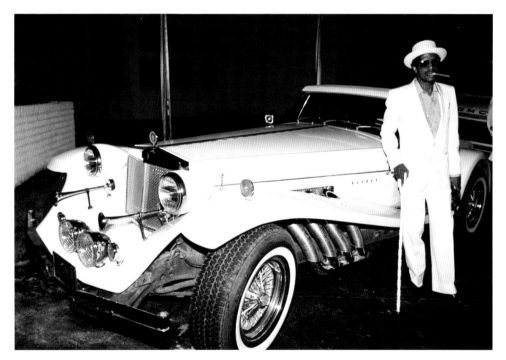

Cecil with Aretha's car, a Clénet.

Aretha had so much fun taking Polaroid photos of her sixty friends and family
in their spectacular costumes. Here she is with her friend Hilton Kincaid.

19 – 88

AUGUST

The Queen on the Presidential Yacht

Aretha invited thirty guests to dress in patriotic colors and board the USS *Sequoia* on the Detroit River. This historic presidential yacht had been known as "the floating White House." JFK held his final birthday there, and Queen Elizabeth used it during her visit to the United States, which means that two queens have enjoyed her. Designed in the 1920s, the one-hundred-foot-long *Sequoia* has a presidential stateroom, guest bedrooms, and a dining room.

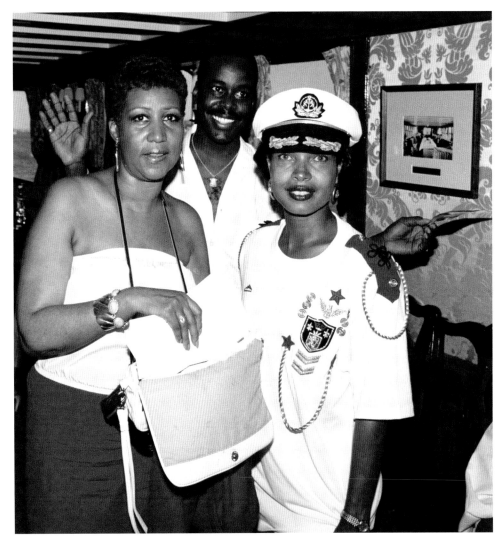

Aretha with friends Hilton Kincaid and Beverly Bradley.

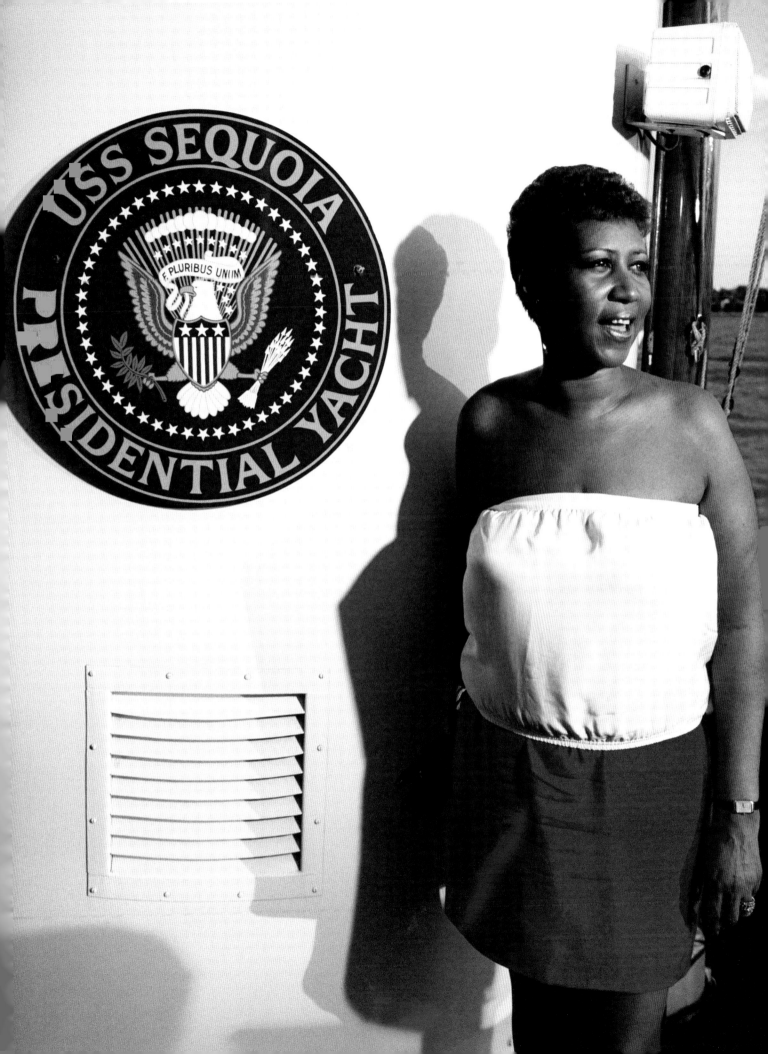

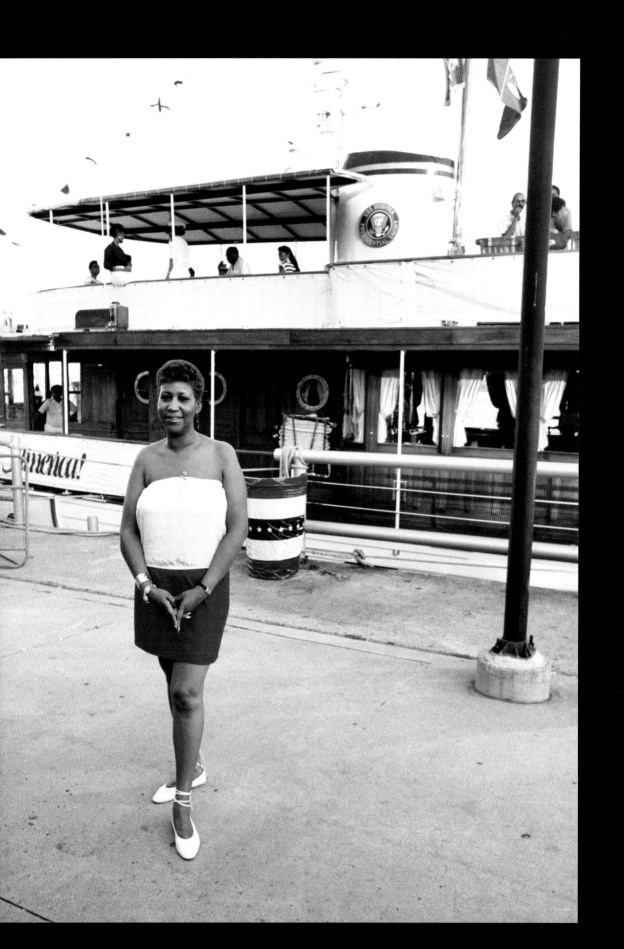

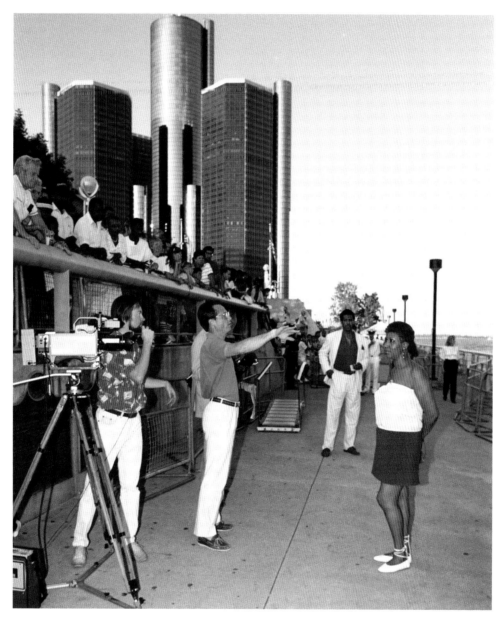

Aretha with the backdrop of Detroit's Renaissance Center.

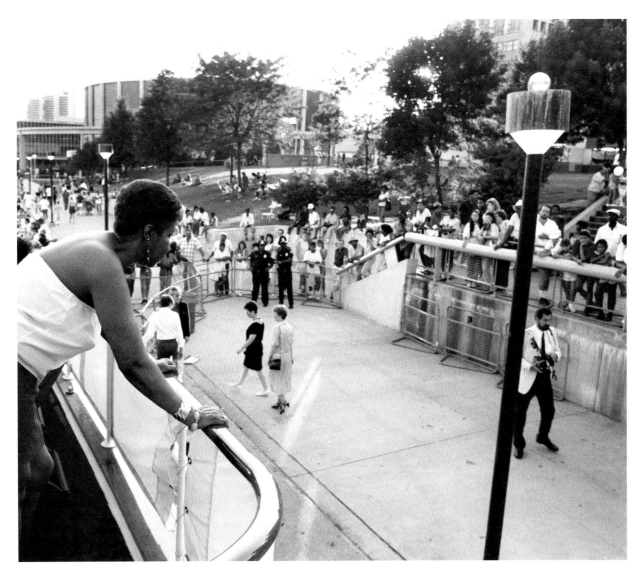

Aretha watching the crowd gathering outside the yacht.

Aretha pretending she had motion sickness.
The handmade carpet in the dining room was
embroidered with the presidential seal. (RIGHT)

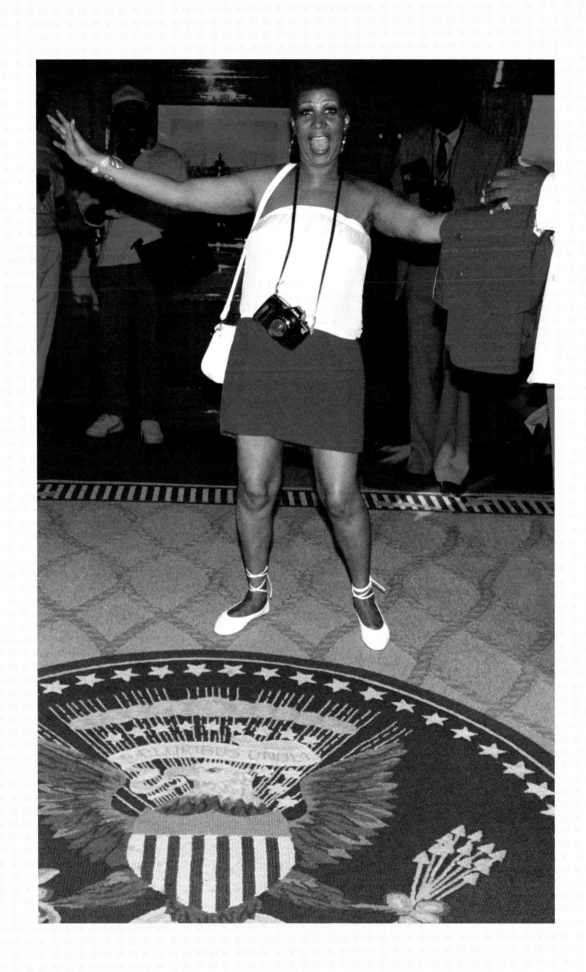

19
—
88
AUGUST

All Alone Before a Concert

Aretha surprised George Michael's audience at the Palace of Auburn Hills when she joined him during the encore to sing their 1987 duet "I Knew You Were Waiting (for Me)." "I love the fact he's crazy about soul," said Aretha in rehearsal. I had the opportunity to photograph Aretha alone in the arena before fans and musicians arrived. This arena seats twenty-three thousand, and the concert was sold out.

Aretha had her camera
with her too.

$$\frac{19}{89}$$

MARCH

Star-studded Birthday Party

———

Aretha hosted a birthday bash every year. For her forty-seventh birthday, she invited seventy guests to her home and welcomed them with mariachis on the driveway. The nonstop entertainment, which she changed every twenty minutes, included not only the mariachis but also Peabo Bryson, Sinbad, and the Jimmy Wilkins Orchestra.

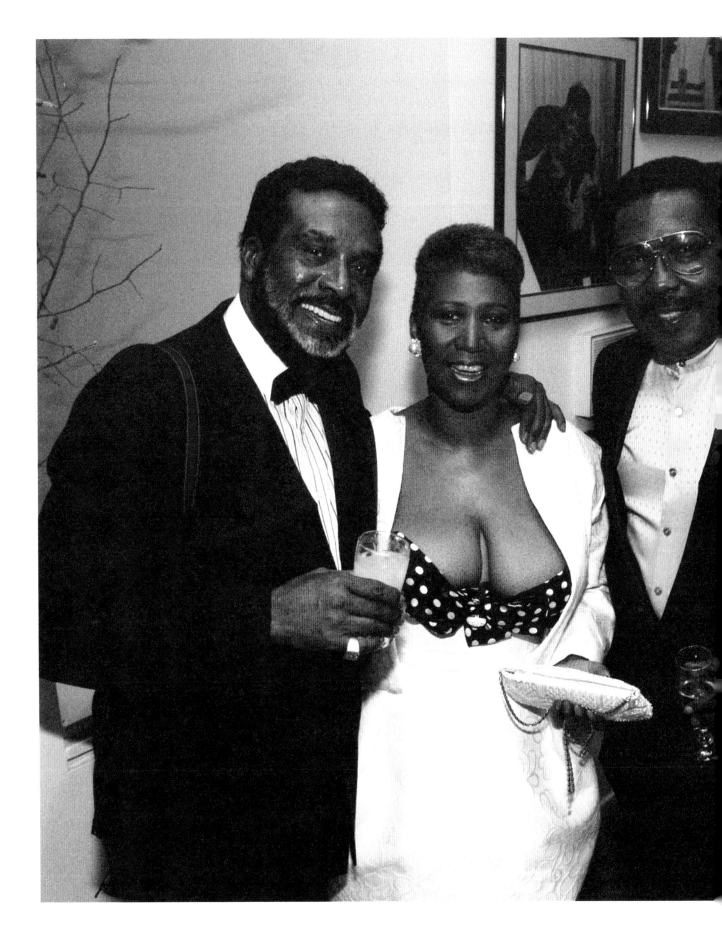

Aretha in the middle of two of the Four
Tops, Levi Stubbs and Lawrence Payton Jr.

Levi Stubbs had his video camera and captured all the fun on film.

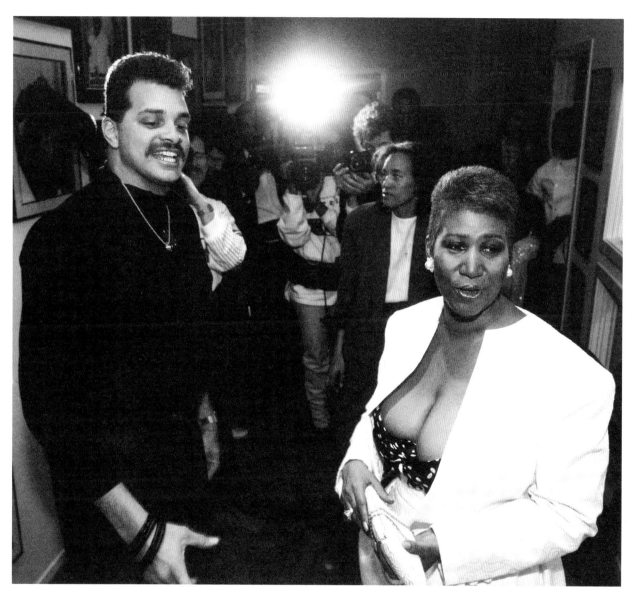

Aretha and comic Sinbad.

A
Gala
Birthday
Soirée

Starring

Monsieur Peabo Bryson
Capitol Records

(Surprise Artist)

Sinbad

International Cuisine (over)

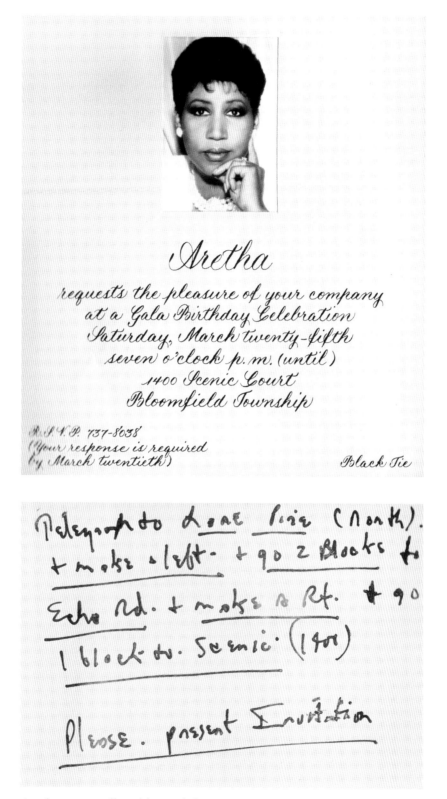

Aretha personally addressed the invitations and added her own
handwritten directions.

19
—
91

MARCH

Aretha's Birthday at the Ritz

———

Aretha's forty-ninth birthday was a glamorous French cabaret party at the Ritz-Carlton Hotel (now The Henry) in Dearborn, Michigan, where she celebrated with two hundred friends and family members. Looking very sexy at her Parisian-themed party, she stopped to look at a special street sign created for the Queen, "Rue D'Aretha." The Count Basie Orchestra provided the dancing music for Aretha and her guests.

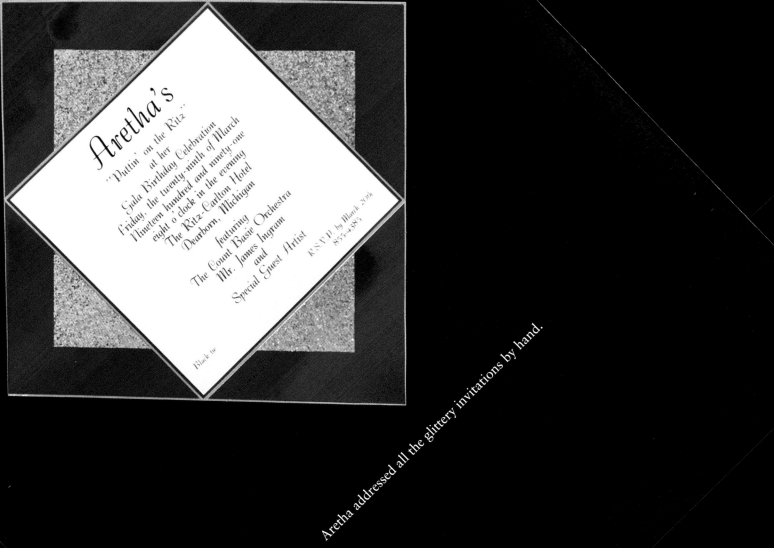

Aretha's

"Puttin' on the Ritz"

at her
Gala Birthday Celebration
Friday, the twenty-ninth of March
Nineteen hundred and ninety-one
eight o'clock in the evening
The Ritz-Carlton Hotel
Dearborn, Michigan

featuring
The Count Basie Orchestra
Mr. James Ingram
and
Special Guest Artist

R.S.V.P. by March 20th
855-4385

Black tie

Aretha addressed all the glittery invitations by hand.

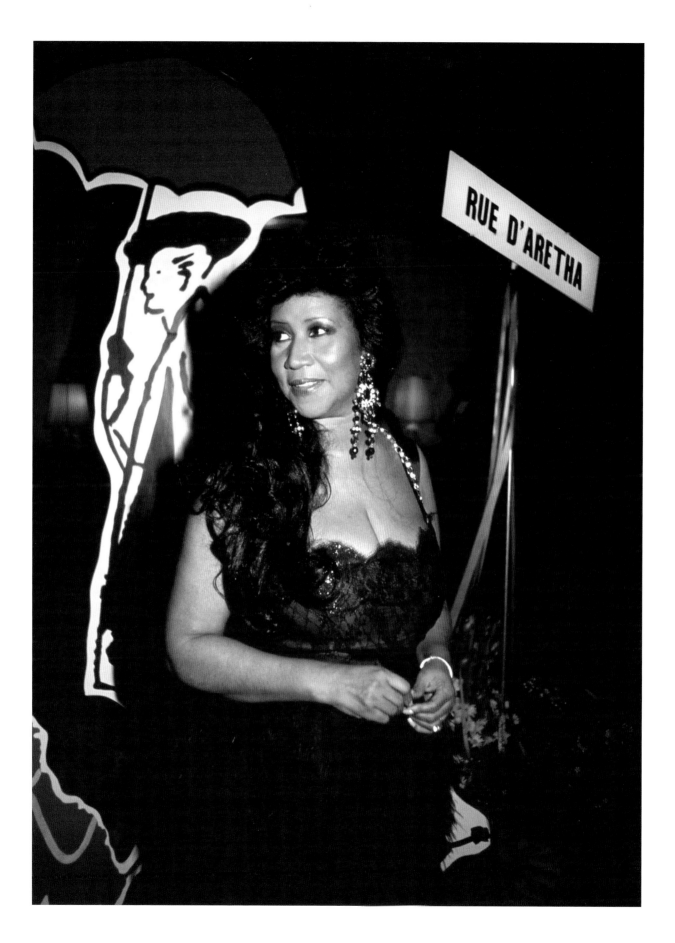

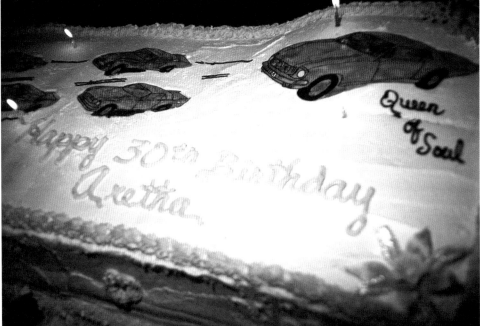

Aretha's "30th" birthday cake featured miniature pink Cadillacs.

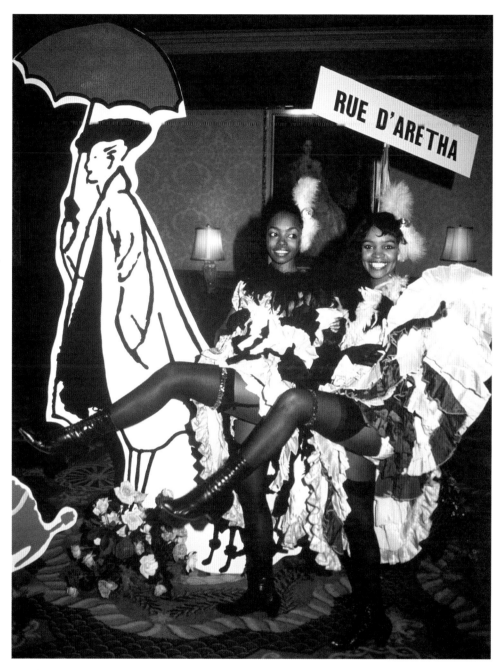

Aretha was studying French and peppered her conversations with French language.

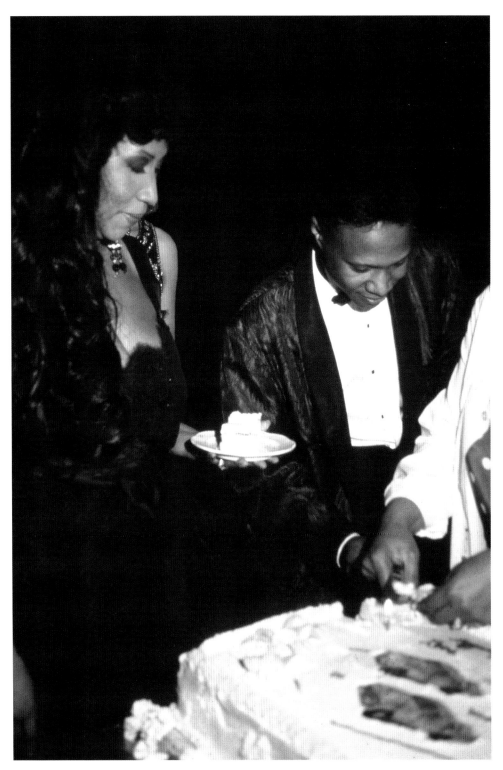

Aretha and her son Teddy cutting the cake.

Musician Melvin Rencher with Erma Franklin.

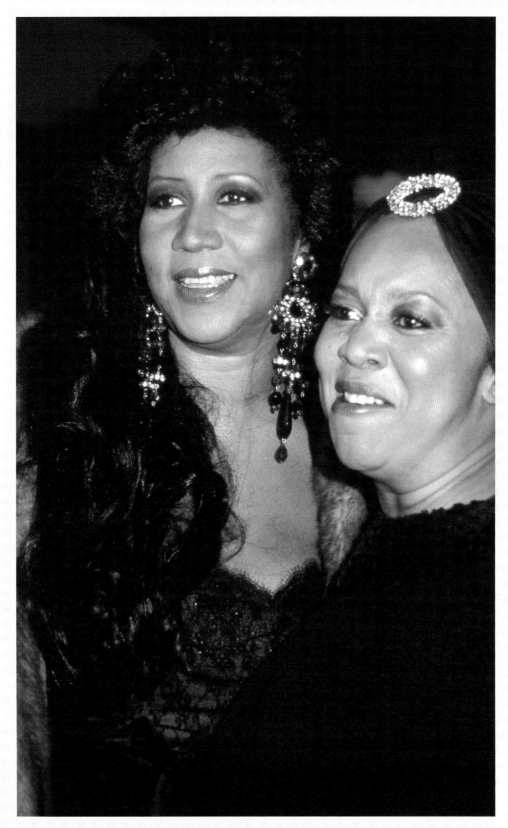

Aretha with Mavis Staples of the Staple Singers. Mavis Staples met Aretha when they were teens performing gospel all over the country with Reverend C. L. Franklin and the Staple Singers.

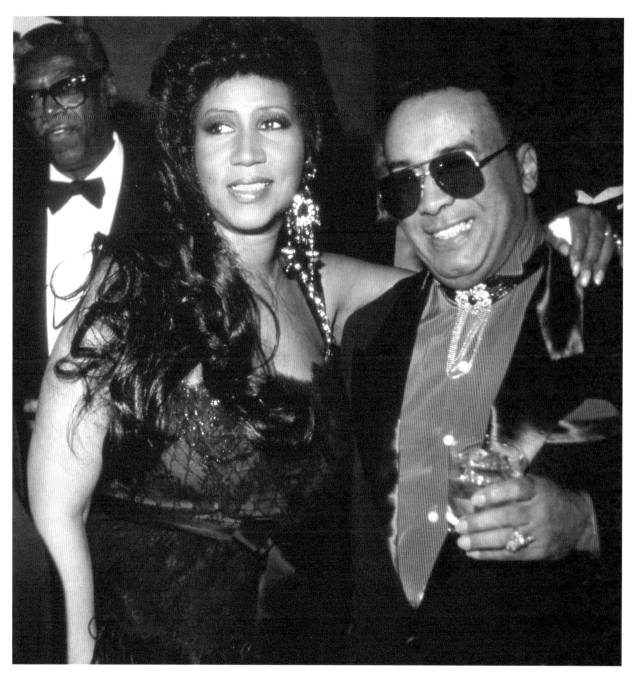

Harry Kincaid Sr. (LEFT), Aretha, and Billy Henderson of the Spinners.

19
—
92

JUNE

Aretha the Ballerina

———

Aretha thrilled the audience at the Waldorf Astoria Hotel in New York when she walked on stage in a tutu. There to celebrate the New York Friars Club Lifetime Achievement tribute to her close friend legendary record producer and music industry executive Clive Davis, Aretha surprised everyone by performing pirouettes with the troupe from the City Centre Ballet Company. My mother and I had flown to New York for the event, but all Aretha told me was that she was going to surprise Davis. Years earlier, Aretha had taken ballet classes; now she was on stage in a tutu with a professional ballet troupe in front of highly accomplished performers.

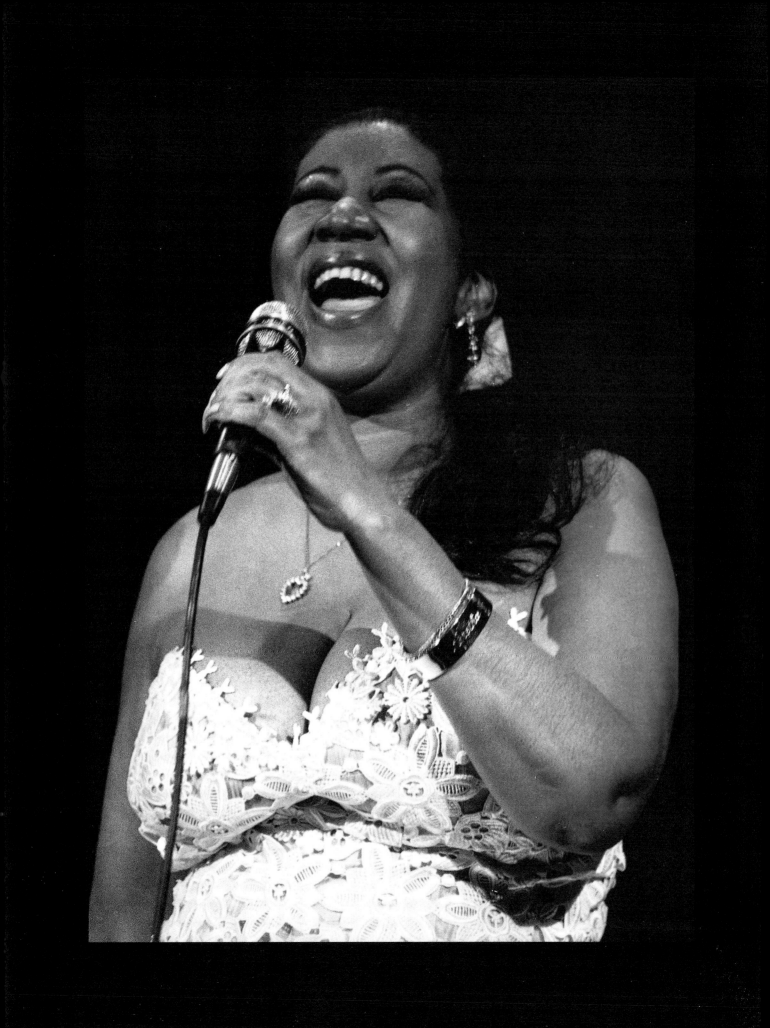

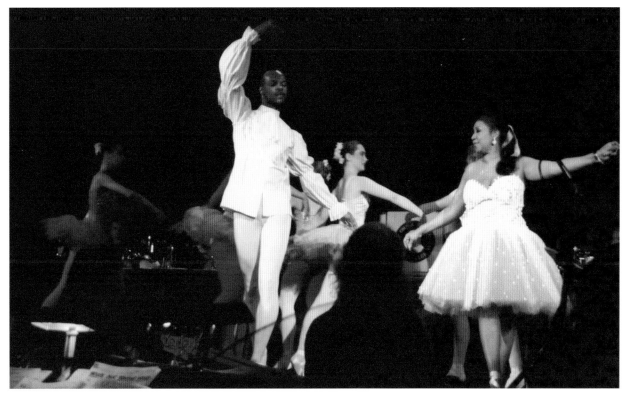

Aretha in a tutu with the troupe from the City Centre Ballet.

Aretha singing
"Everyday People." (LEFT)

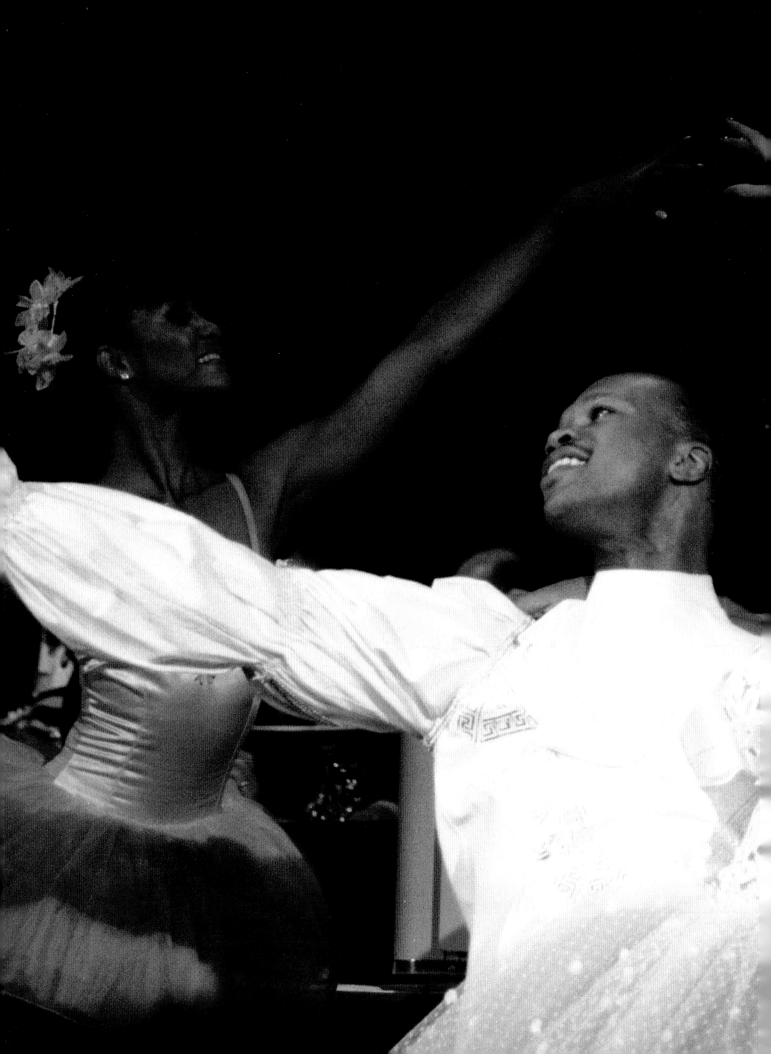

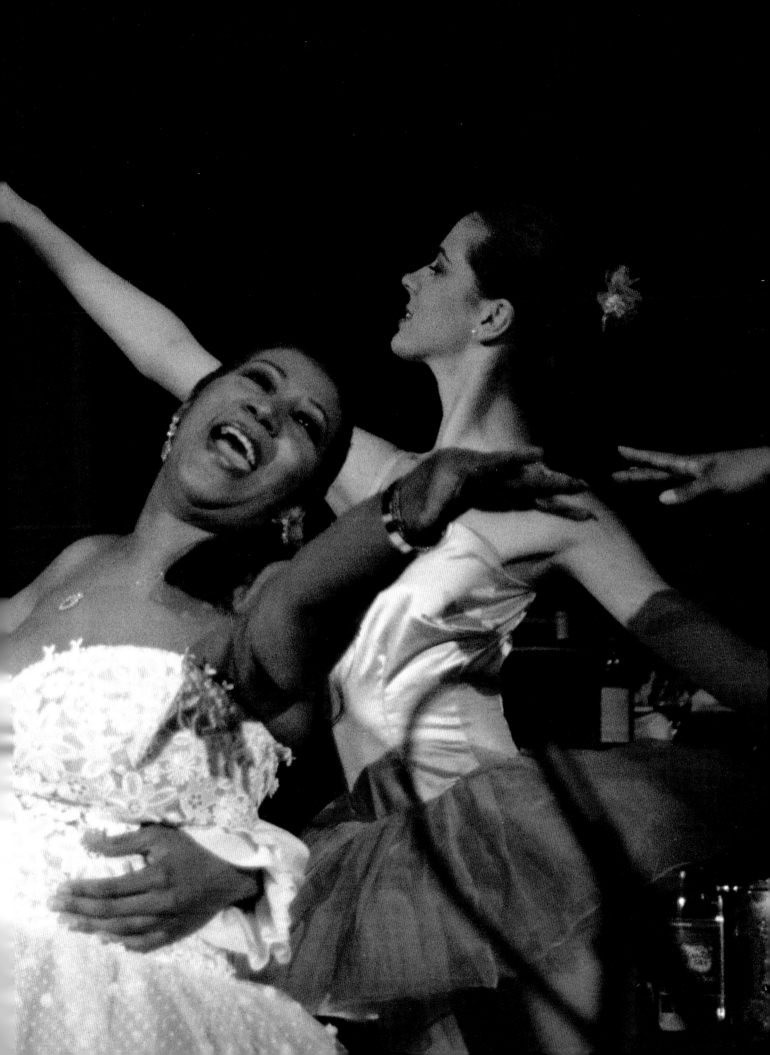

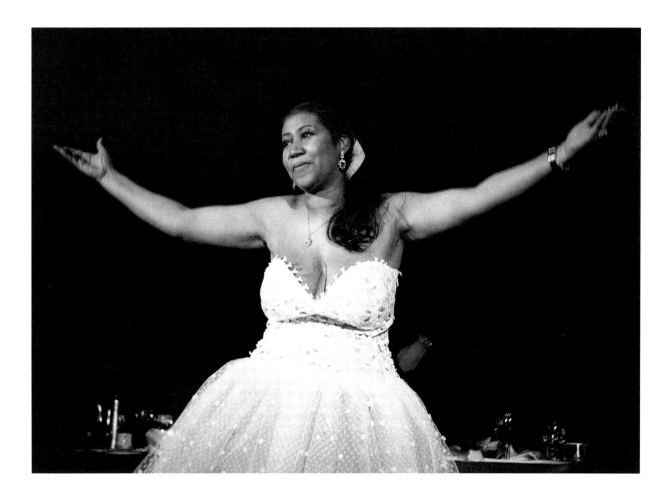

She accompanied herself as she sang
"Bridge Over Troubled Water." (RIGHT)

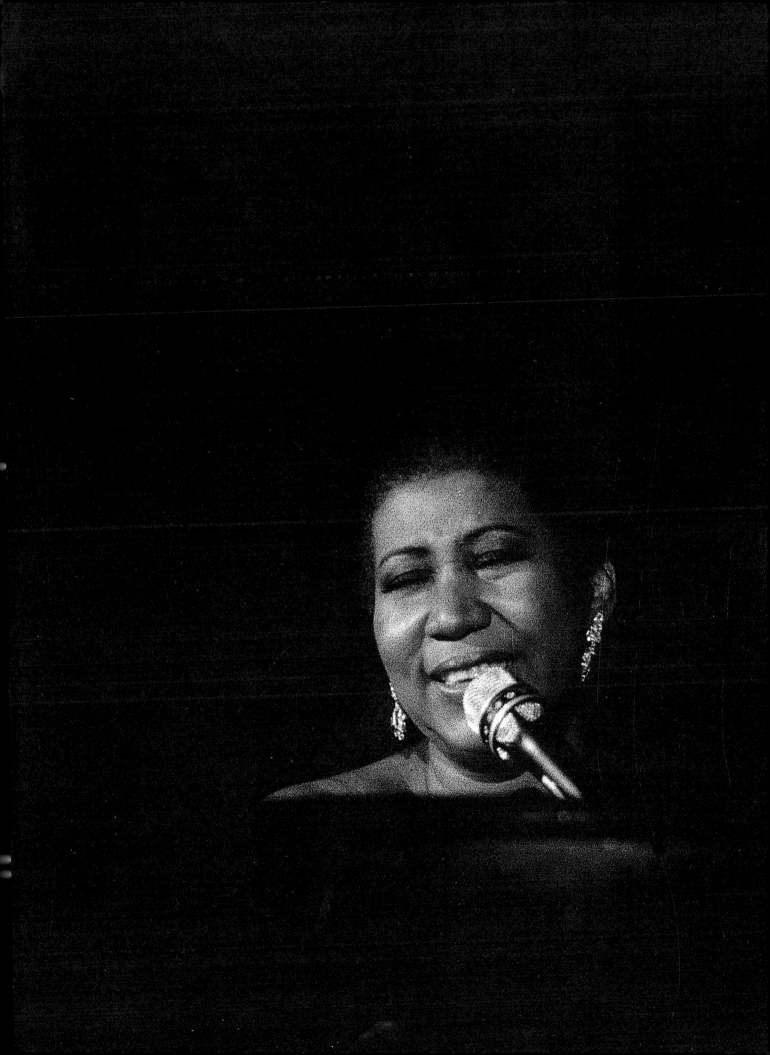

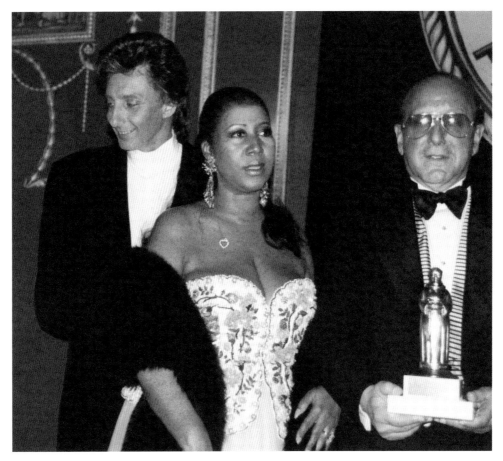

Aretha with Barry Manilow and producer Clive Davis.

Aretha and lyricist Sammy Cahn and his wife, Tita Cahn; Susan Lucci; Kenny G; and Barry Manilow.

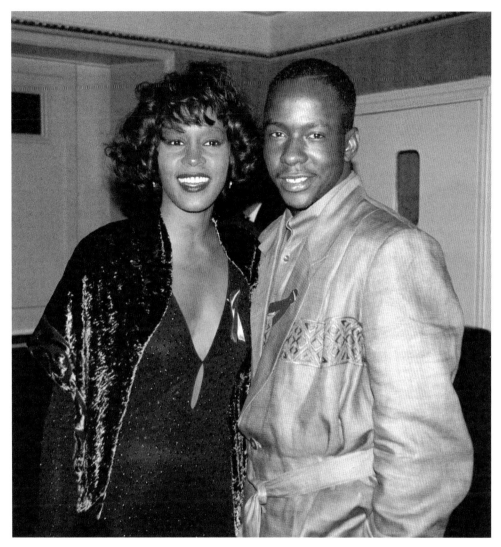

Whitney Houston and Bobby Brown. Whitney called Aretha "Aunt Ree"
and said Aretha was one of her greatest musical inspirations. Cissy Houston,
Whitney's mother, performed and toured with Aretha and did background
vocals on many of Aretha's hit songs in the late sixties.

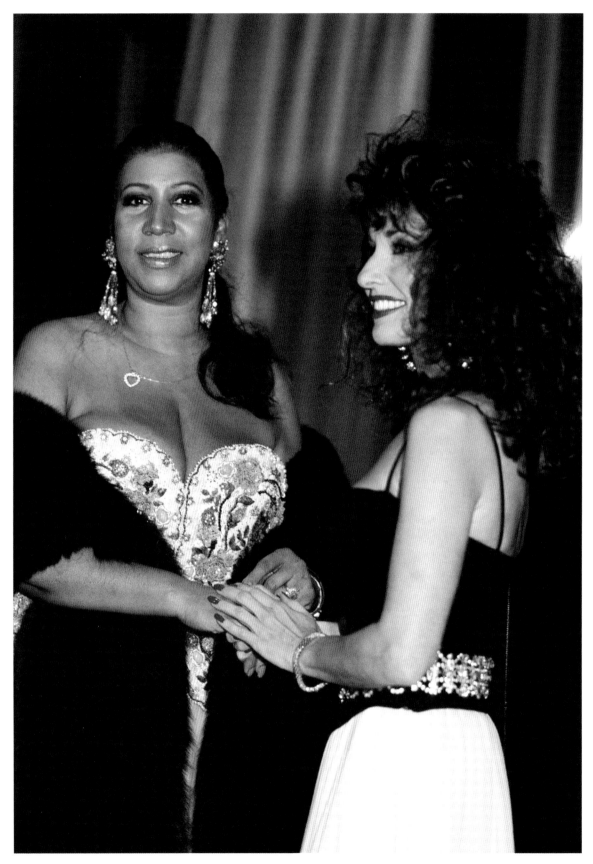

As a lifelong "soapie," Aretha was so excited to meet actress Susan Lucci.

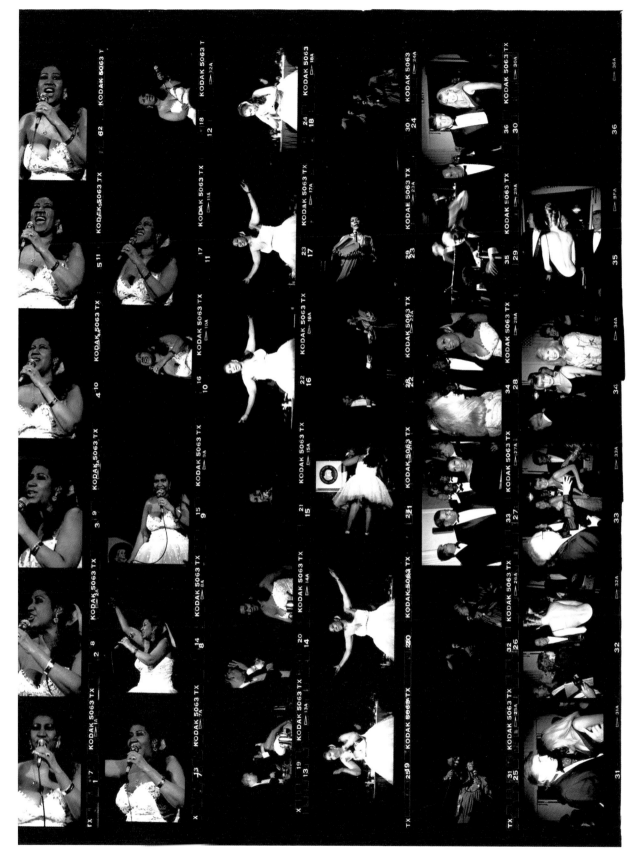

Contact sheet for the black-and-white pictures from the event.

19
—
98

NOVEMBER

Aretha's First Performance with the Detroit Symphony Orchestra

A retha wowed the audience in the majestic Orchestra Hall in Detroit with her first performance with her hometown symphony. Her symphony concert in Detroit was special not only for the way she included her family members and the longtime musical director but also because she showed how important it is to keep learning and expanding. Some months earlier, Aretha caused jaws to drop when she performed the Puccini aria "Nessun Dorma" at the Grammys.

She stepped in for her friend Luciano Pavarotti, who canceled his performance less than an hour before he was to appear. She created one of the greatest performances in the history of the Grammys. The DSO audience in Detroit loved her aria too. She received multiple ovations and was presented on stage with flowers by Detroit Mayor Dennis Archer. She continued to study opera for the next twenty years of her career. It was very special to be able to photograph her during the rehearsal from beside her on stage.

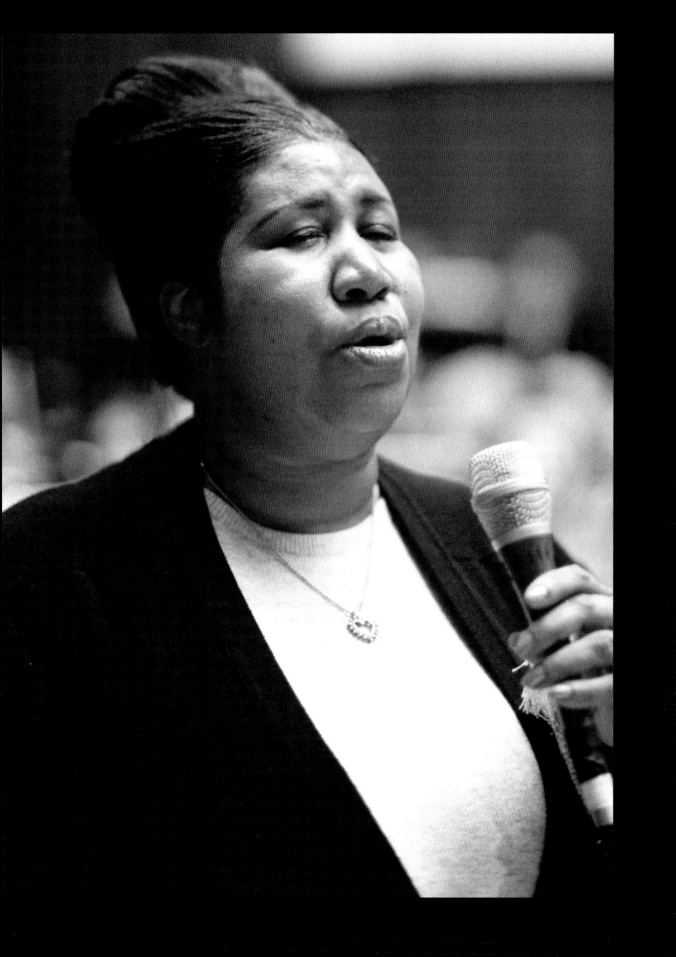

Aretha's son Teddy played lead guitar.

Aretha's handbag was on the piano during the rehearsal and in concert. As the story goes, Aretha always had her handbag on stage because she was paid half in cash and her handbag had all the cash. This way she could pay her musicians in cash immediately after the performance.

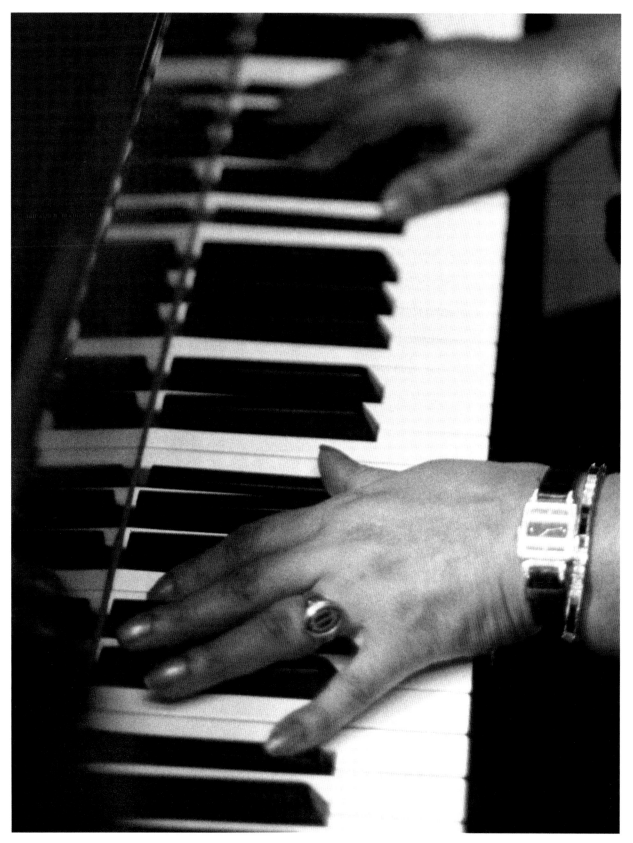

Aretha as her own piano accompaniment during rehearsal. As a child she always admired how her sister Erma played classical music on the piano. It was always so special for me to photograph her at the piano.

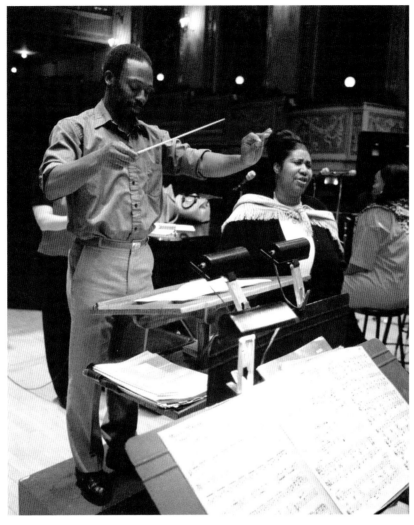

Aretha with conductor Dr. Leslie B. Dunner.

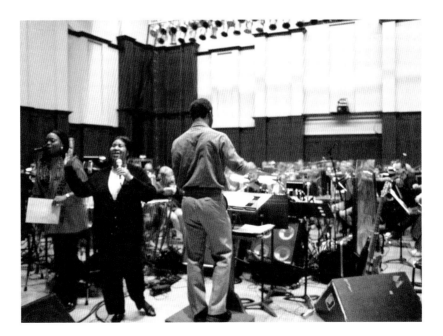

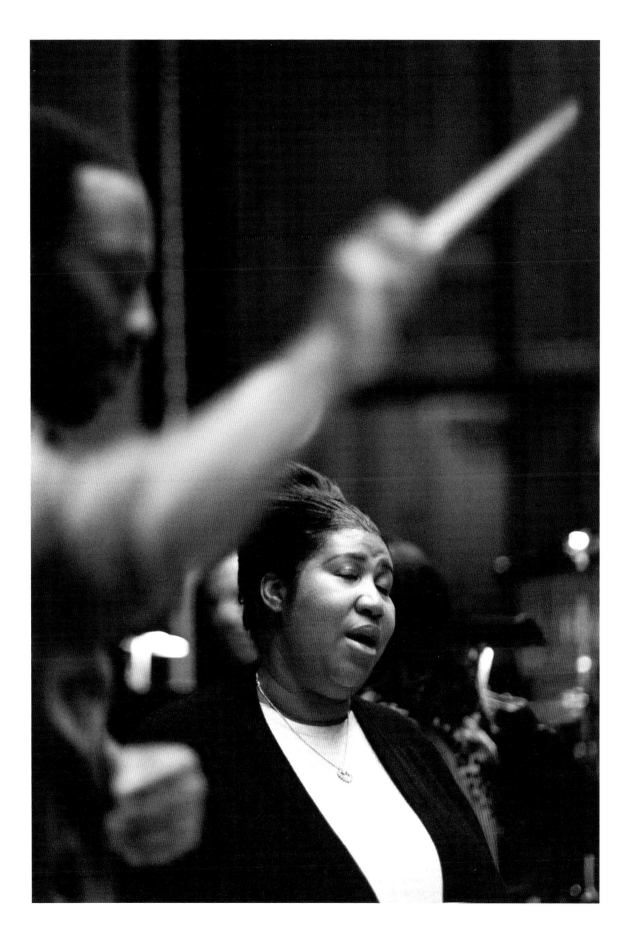

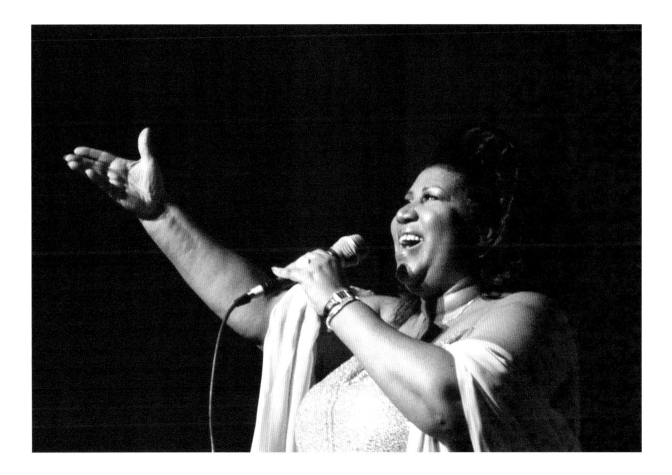

20
—
07

AUGUST

In the Hamptons with Her Grandchildren

———

What a fun time we had getting two families together in the Hamptons, where Aretha spent her summer vacation in New York. My sister Jill lives in the Hamptons, and she hosted a party at her farm in Aretha's honor. I flew to New York with my mom. Aretha brought her family—son Kecalf, his wife, and her three grandchildren. Her friends Willie Wilkerson and Hilton Kincaid from Detroit were there too. Jill's guests included Russell Simmons, Kelsey Grammer, and Katie Couric. I only wish I had the photo captured by the Queen Next Door . . .

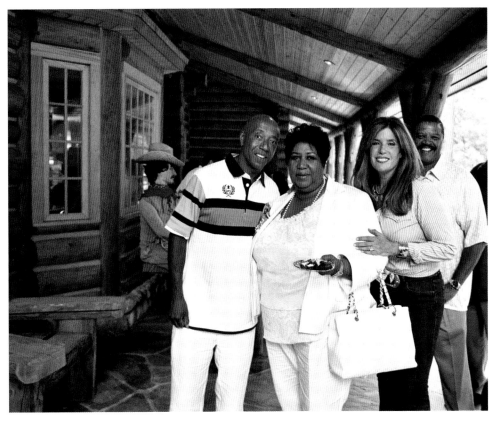

Aretha and Russell Simmons with my sister, broadcast journalist Jill Rappaport, and Willie Wilkerson.

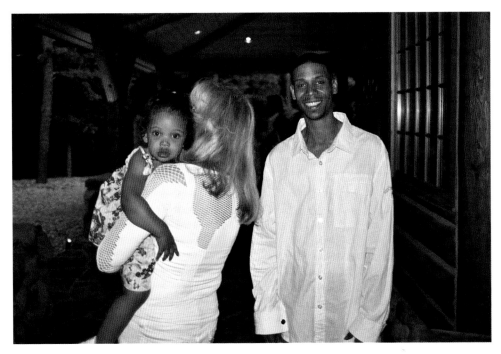

Aretha's son Kecalf Cunningham and his daughter, Aretha's granddaughter Grace, with my mom, Mona Rappaport.

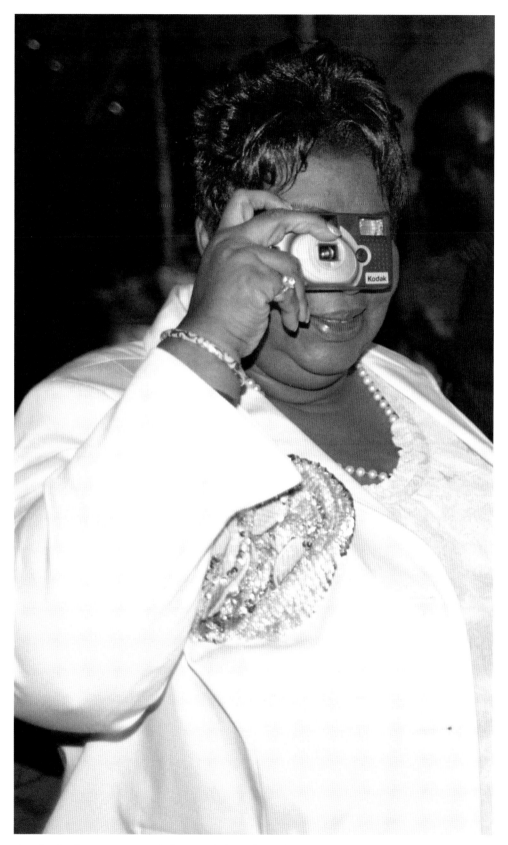

Aretha had a camera with her and she asked if she could take one photo of me just like I had asked her over thirty years ago.

20
—
18

AUGUST 31

RESPECT

The sun was shining in Detroit as I drove on the freeway with my camera case next to me. The early morning light of late summer was overshadowed by my sadness. Aretha's niece Sabrina had invited me to photograph the Franklin family and her beloved aunt's closest friends, who gathered privately at the St. Regis Hotel in Detroit before the memorial church service for Aretha.

The location of the family reception was kept a secret.

No other cameras allowed.

No media.

Media from all over the world waited in their satellite trucks and in their designated places at Greater Grace Baptist Church.

As I photographed the family, I realized how many years I had known the Franklins.

Aretha's grandbaby Grace, whom my mother had held in her arms, is now a beautiful young teen.

Aretha's niece Sabrina is now a grandmother. Sabrina's son LaRone, now forty-three, told me he remembered the photo I had published of him with his mom when he was ten years old. Aretha's little niece Cristal now has a twenty-two-year-old daughter.

This Franklin family gathering was without Aretha's jubilant younger sister, Carolyn.

It was without Aretha's older sister, Erma, who made everyone, including me, always feel special, like family.

It was without Cecil, who would have been busy organizing all the details to make sure everything—and I mean everything—was perfect for his baby sister.

And . . . this family gathering was without Aretha.

One word, "R E S P E C T," was featured on all Detroit landmarks, on building marquees, and painted on handmade signs—some by kids who were the same age I was when I first bought that 45 at Kresge's.

Kresge's is now gone.

Decades have passed.

But R E S P E C T is forever.

As we drove together to the church, thousands of Detroiters of all ages stopped everything in their lives to pay their respects to the Queen.

And I will always respect and cherish that the Queen let me photograph "the lady next door."

LINDA SOLOMON
Photojournalist

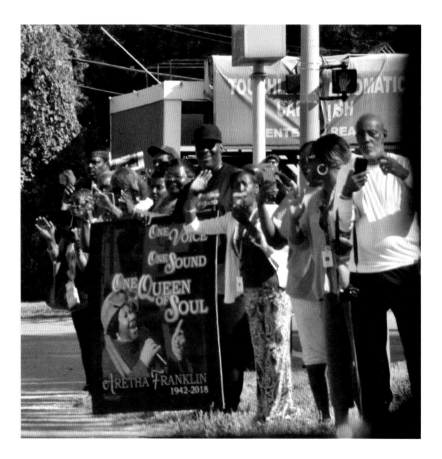

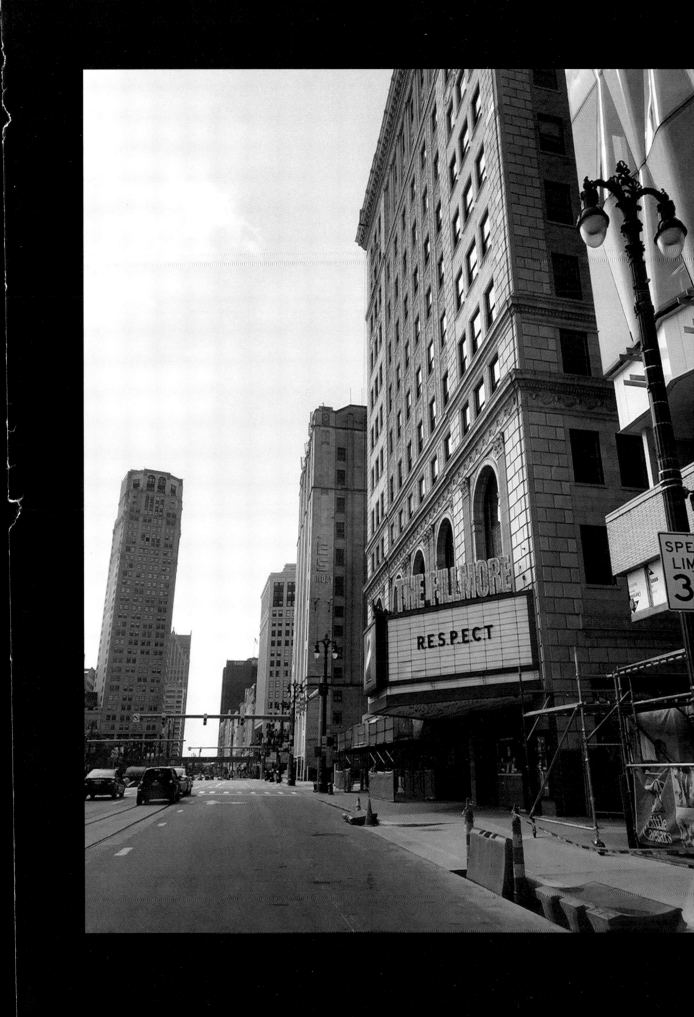

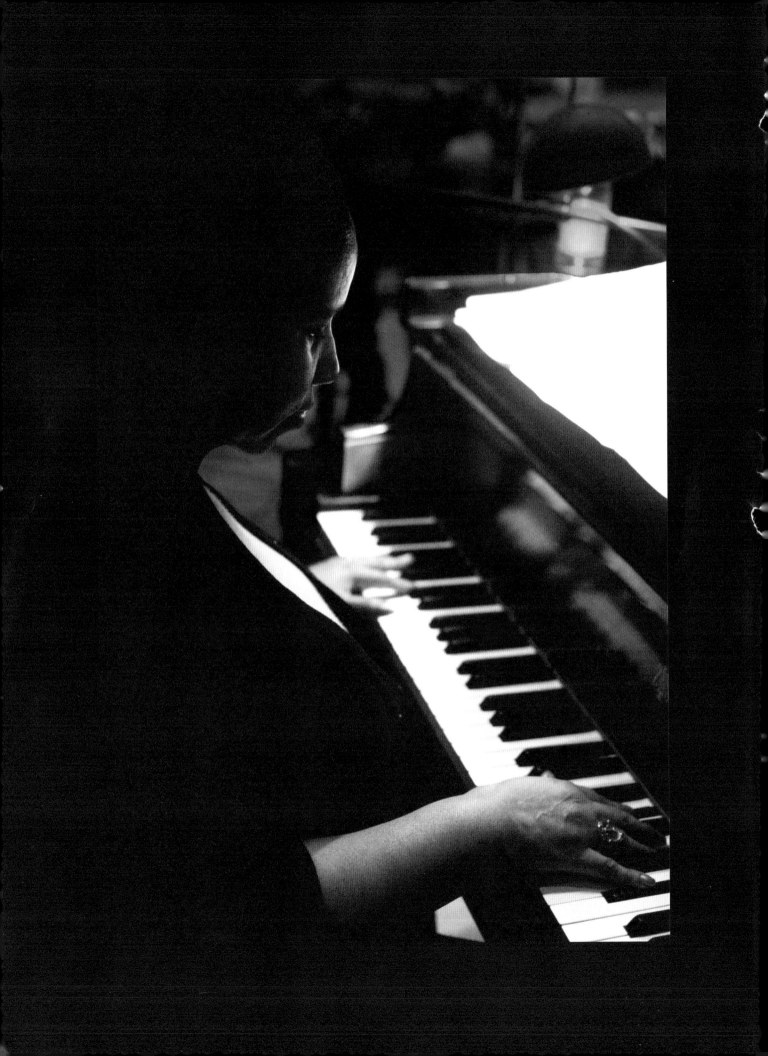

AFTERWORD

It is an honor and privilege to be a member of the Franklin family, with our long and rich history in the city of Detroit. Civil rights, entertainment, and social activism have long been a part of our history, much of which has been captured in the media and in pictures, many by Linda Solomon.

When I think of it, I actually don't remember the first time I met Linda. She just seems to have always been there, quietly and unobtrusively in the background, capturing images of my family. However, when I look at the multitude of pictures Linda has taken, I realize that I have known her since the time my son, LaRone (now an adult), was around five years old. While Linda was initially introduced to the family by my Uncle Cecil, my mom (Erma Franklin), thought the moon and sun revolved around Linda. You could often find them huddled together at Aretha's birthday and holiday parties, sharing a secret story or a laugh. It's humbling to think that she has been devoted to capturing amazing images of my family for decades, many of which are maintained in my Aunt Aretha's personal archives.

My aunt once said, "When I'm not on stage, I am the lady next door." This was so true, as it was during this downtime that Aunt Aretha would read voraciously (mostly biographies and history), revisit her many pictures, call for girl-talk, or watch her favorite soap opera, *The Young and the Restless*. Those are the moments that my family will miss most. It was not uncommon to receive a call from her on a Sunday afternoon or weekday night and have the call last for an hour, or more. She enjoyed discussing politics, local and world events, and gossip! She wanted to know what was going on with you. She would ask, "How was your day?" and show genuine interest. She wanted to know what your day was like, what good movies you'd seen, or hear about your vacation plans.

Family meant everything to my aunt. With the loss of her siblings (our parents), she became the matriarch of the family, guiding,

coaching, mentoring, and supporting us through life's challenges and rooting for our successes. She had a kind and generous spirit about her, and often extended invitations for us to join her on visits to the White House. She invited us to see the Pope during his U.S. visit, to attend the Kennedy Center Honors and award shows, on summer visits to the Hamptons, on shopping trips to New York and LA, and to her own spectacular concerts. We loved spending time with my aunt and cherished those moments when we could all travel together as family.

Linda captured so many of these special moments. Consequently, I was not surprised to learn about her Pictures of Hope project, because her spirit and smile shine as brightly as the photos she took. Anyone who knows Linda quickly understands how genuine and caring she is. Her compassion far exceeds her images. She often offers her services above and beyond that of a photojournalist. She becomes that caring friend that everyone should have, and I cherish the friendship that we have developed over the years.

All children need HOPE. It is the thread that binds them to the rest of the world that sometimes forgets those who are less fortunate. I have always believed in the old adage, "If you can see it, you can believe it; and if you can believe it, you can achieve it." Pictures help you to see the possibilities of your future, and that's what the camera has done for these children. It shows them that their world does not begin and end with their current circumstances. The possibilities are endless! There is a better world out there waiting for them if they could only be given opportunities to share in the proverbial level playing field.

Regardless of our social and economic backgrounds, we have all had challenges and obstacles to overcome, and life is made easier when one has a loving and caring support system, family, and friends. God bless Linda for caring enough about these children to show them that they are loved and can achieve anything they set their minds and hearts to do.

I thank Linda for being there to capture the life of my family. Through her images, our story will continue to be shared with generations of Franklins to come.

SABRINA VONNE' OWENS
On behalf of the Franklin Family